UNDERSTANDING ABSTRACT ART

UNDERSTANDING ABSTRACT ART

By FRANK WHITFORD

E. P. DUTTON NEW YORK

Published in the United States by E. P. Dutton,
a division of NAL Penguin Inc.,
2 Park Avenue, New York, NY 10016.

First American Edition

Created by Roxby Art Publishing Limited
a division of Roxby Press Limited
98 Clapham Common North Side
London SW4 9SG

Editor: Elizabeth Drury
Design: Neil H. Clitheroe
Typesetting: Tradespools Limited
Reproduction: J. Film Process Co. Ltd, Thailand

Library of Congress Catalog Card Number: 87-70751

ISBN: 0-525-48343-8

Printing and Binding: New Interlitho, Milan, Italy

ACKNOWLEDGEMENTS

The idea for this book was Elizabeth Drury's. She was also of enormous help during its preparation and writing. Without her patience, advice, enthusiasm and practical assistance I should never have begun, let alone finished it. She submitted the text to her outstanding editorial skills, suggested and acquired illustrations and compiled the artists' biographies. I am most grateful to her.

I must also thank Paddy Seymour for her editorial work and Cathe Carpenter and Damien Wilkins for picture research. Thanks are also due to the following for their help in providing illustrations: The Lefèvre Gallery, Marlborough Fine Art, Annely Juda Fine Art, Alex Gregory-Hood at the Juda Rowan Gallery, David Ellis-Jones, Helen Windsor and Miranda North Lewis of Christie's, Philippe Garner and Jane Alway of Sotheby's, Tatiana Browning, J. P. Schmid and Annelee Newman.

CONTENTS

INTRODUCTION	**8**
PART ONE	**11**

CONFRONTING ABSTRACT ART

MONDRIAN: COMPOSITION WITH BLUE AND YELLOW	12
KLEE: PARK NEAR L(UCERNE)	20
KANDINSKY: IMPROVISATION NO. 30	26
MATISSE: THE SNAIL	30
POLLOCK: ALCHEMY	33
SCHWITTERS: OF SOUTH AFRICA	38
RILEY: CATARACT 3	42
MIRÓ: TIC TIC	44
MALEVICH: SUPREMATIST COMPOSITION: WHITE ON WHITE	46
NEWMAN: CATHEDRA	52
LOUIS: THIRD ELEMENT	58

PART TWO	**61**

TRACING ABSTRACTION

ART AND ILLUSION	62
SEEING AND KNOWING	63
SYMBOL AND ALLEGORY	64
ART AND THE ACADEMY	66
PAINTED MUSIC	70
NIGHT CAFÉ	75
ART AND PSYCHOLOGY	78

THE REAL AND THE ILLUSORY 82
ACHIEVING ABSTRACTION 83
CUBISM AND ABSTRACTION 97
PAINTING THE FUTURE 101
ART AND REVOLUTION 106
DE STIJL 109
ABSTRACTION AND THE SUBCONSCIOUS 112

PART THREE 115

ENJOYING ABSTRACT ART

PART FOUR 127

SEEING ABSTRACTION

ORGANIC ABSTRACTION 130
GEOMETRIC ABSTRACTION 132
GESTURAL PAINTING 134
COLOUR-FIELD PAINTING 136
OP ART 138
HARD-EDGE PAINTING 140
SHAPED CANVAS 142
MINIMAL ART 144

APPENDIX 147

CHRONOLOGY 148
ARTISTS' BIOGRAPHIES 149
LIST OF ILLUSTRATIONS 154
BIBLIOGRAPHY 157
INDEX 159

INTRODUCTION

We must not be afraid of this word 'abstract'.
All art is primarily abstract.
Herbert Read, *The Meaning of Art*

This is wise advice, but it might be as well to define the word 'abstract' before using it. Although Herbert Read asserts that all art is primarily abstract, that it is essentially about harmonious arrangements of forms and colours, all art is not the subject of this book. What follows is an attempt to examine specifically those kinds of art which do not aim to represent any part of the familiar, visible world.

Most people use the word 'abstract' to describe this kind of non-representational art, but some artists have preferred to employ other, according to them, less misleading terms, which they may have coined themselves. Kandinsky, one of the earliest such painters, preferred the term 'non-objective'. Mondrian used 'Neo-plasticism' to describe what he was doing, an intimidating translation of a less portentous Dutch phrase better rendered as 'a new kind of reality'. Other artists spoke or wrote of 'concrete', or 'pure' or 'constructed' art, while art criticism has given wider currency to the word 'non-figurative'.

Every artist, critic or other kind of expert has good reasons for preferring one term to another. The easy way out is to adopt the word that is most widely understood. From now on, therefore, the quotation marks are dropped from the word abstract.

Whether the word abstract or a synonym is used, a definition remains difficult, perhaps impossible, to achieve. Just as all art is primarily abstract, all abstract art is, in a sense representational. Some abstract paintings intentionally allude to aspects of the familiar world; others unintentionally evoke them. It is difficult to invent an image which will not remind the viewer of something. The urge to see a face in every circle is irresistible. Even a perfect horizontal line bisecting a rectangle will look like a landscape.

Abstraction does not describe a style of painting. It is not a word like 'Baroque', for example, which is applied to the roughly similar work of a large number of artists to define what it is that they have in common. Abstraction is not a style but an attitude. Potentially, there are as many

types of abstract art as there are artists. No stylistic definition, however broad, can embrace the work of painters as different as Kandinsky and Malevich, Mondrian and Pollock.

Many people experience difficulties when confronted by an abstract painting. In spite of the fact that abstraction is the best part of a century old, that plainly serious painters have devoted most of their lives to producing it, that the most famous museums throughout the world have large sections devoted to it, not everyone is able to take it seriously. Even fewer people can honestly say that, in their opinion, abstraction has produced a single painting of a seriousness and a complexity to rank with any of the great masterpieces of the past.

Certain questions are tenacious. Shouldn't painting be primarily concerned with the faithful transcription of a world which everyone can recognize? Shouldn't the talent of a painter be judged largely in terms of the skill with which he transcribes that world on to canvas? What is the difference between an abstract painting and the pattern on a plate or a piece of wallpaper?

What follows sets out to answer these questions and others like them. It is by no means an apologia for abstract painting. Some of the answers may not be what is expected from a book of this kind. The book is an attempt to illustrate the variety of abstract painting, to explain its intentions, uncover its roots and trace its development. It is also an attempt to measure the success of abstract painting in its own terms. Does this or that abstract painting affect the viewer in the way the artist intended? If not, what effect does it have and how does it achieve it?

Only abstract painting will be discussed, although abstraction is by no means confined to that medium. During this century many sculptors have made non-representational works on every imaginable scale and in every imaginable material. Even movies have been affected by abstraction and a small number of film makers have animated geometric and other forms, thus introducing an entirely new (and visually exhilarating) kind of cinema which, although highly experimental, has not been without influence on more conventional kinds of film. Literature, too (especially poetry), has been affected by abstraction in the visual arts. Some writers have been inspired to use words not for their dictionary-defined meaning but for their sound alone and to arrange them not in ways dictated by the rules of grammar and syntax but to create rhythms and melodies.

Sculpture is not discussed in this book. It can be argued that, since sculpture is the art of making tangible, three-dimensional and therefore palpably real objects, it is more suited to abstraction than painting which is an art of illusion. Certainly, abstract sculpture occupies an important place in the history of modern art and, because many large abstract sculptures can be seen in public places, it is more visible than abstract painting which is mostly confined to museums.

The long development which produced abstraction was virtually confined to painting; the first abstract work ever made was a painting

and the first abstract sculpture was made under the influence of painting; the theoretical considerations which provided the impetus for abstraction were initially only of painting. Most of the discussion of painting which follows does, however, apply with equal force to sculpture.

Understanding Abstract Art is not a history of abstraction. It does not set out to examine the work of every major abstract painter or even every abstract style. Rather, it attempts to ask and answer questions about abstraction and to suggest a number of approaches to the understanding and appreciation of abstract art. It prefers to be specific and detailed before being general and diffuse. Let us therefore begin with a close examination of a single abstract painting and of possible reactions to it.

PART ONE

CONFRONTING ABSTRACT ART

MONDRIAN: COMPOSITION WITH BLUE AND YELLOW

Of what does this painting by Piet Mondrian, *Composition with Blue and Yellow*, consist? The most obvious answer is: very little. It consists only of two colours, and black and white, four vertical and five horizontal lines.

That description is obviously inadequate for it gives nothing more than a vague notion of the appearance of the picture. A more considered answer to the question must take other factors into account.

For example: the yellow area is almost a square, while the blue sits in a very much smaller rectangle. To the right of the yellow square, and separated from it by the tall, narrow space between the two vertical lines, is a slightly larger, whitish space. All the lines form rectangular areas between them. Some of these areas are identical, some quite different in size and shape. The rectangles at the four corners of the picture (which is itself almost a perfect square) are described on two sides by painted lines, on the other two by the edges of the canvas.

The precision with which the picture seems to have been planned and painted invites such a dry description. At first sight the picture looks more like a magnified detail from some coloured technical drawing than a work of art. Yet what initially appears to be a dryness, a blandness within the picture, is on closer inspection enriched by tiny and subtle modifications. The lines are in reality not precisely drawn but of slightly varying thickness, with edges that are not perfectly straight. Moreover, what appears in the reproduction to be a smooth, anonymous surface is revealed in the original picture to consist of thick, even creamy, paint. As this and the reticent signature in the bottom right-hand corner make plain, the picture is not the product of a machine but of a man who took delight in the qualities of the paint with which he made it.

Only a careful inspection of Mondrian's picture reveals subtleties such as the varying thickness of the lines. Subtleties of a different kind emerge with even closer inspection. Undeniably the painting seems balanced: all the elements appear to have been brought to a state of equilibrium. Yet the balance has not been simply or obviously achieved

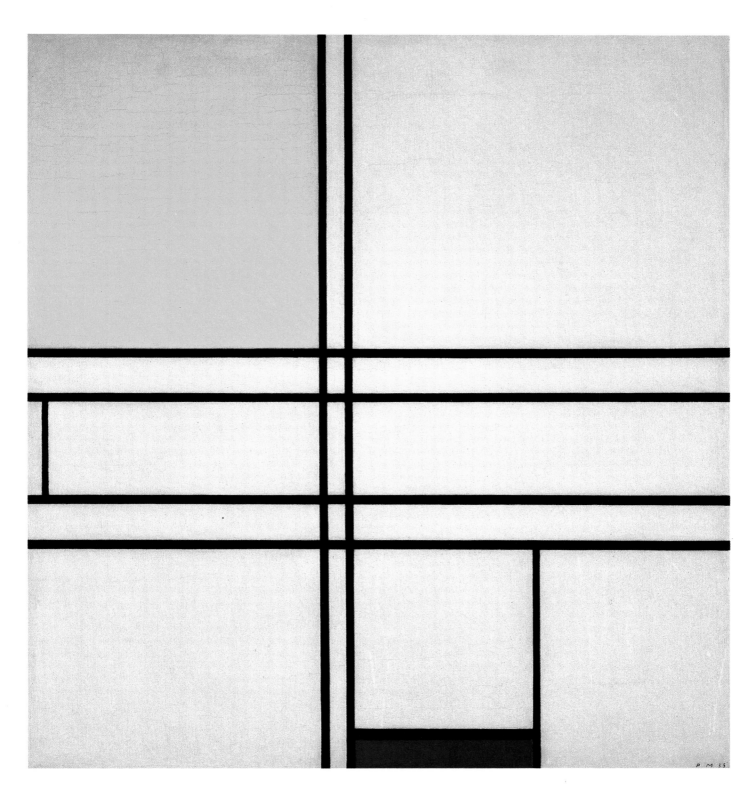

Piet Mondrian (1872–1944), *Composition with Blue and Yellow*, 1935.

Photograph of Mondrian in his Paris studio, *c.* 1930.

by, for example, the repetition of identical shapes or colours. The vertical lines do not bisect the canvas; very few of the areas which they and the horizontals describe are identical in volume. It is an equilibrium of disparate elements.

Because the elements are different but similar, their arrangement repeatedly invites comparison between the relative volume of one area and another. Is the small, narrow space at the far left precisely the same as the other to the right and towards the centre? What are the proportions of the rectangle at the bottom left and that at the top right? Might they even be the same?

Such questions force the viewer to scan the painting, mentally weighing and measuring all the elements within it and defining the relationship between them. This process of scanning creates an impression of movement, of tension between the various parts of the picture. Gradually, it becomes apparent that the balance has been achieved by a dynamic arrangement of shapes, the weight and volume of which are pulling in different directions.

Colour is important, too. Apart from the greyish white and black, there are only two of them: yellow and blue. These are two of the three primary colours (the other is red), from which all other colours can be obtained by mixture. They have a strength and a purity unequalled by the secondary or tertiary colours derived from them, and each has an obvious character that is sharply distinct from the next.

The yellow square, although smaller than the rectangle at the top right, appears stronger, demands more attention because its colour is more assertive than the neutral white. Its strength is counterbalanced not only by the small area of the darker blue at the bottom but also by the introduction of the short vertical line – one of only two in the picture which do not extend from edge to edge of the canvas. Together they create an area of relative complexity which counters the attraction of the yellow and results in equilibrium.

It is easy to demonstrate the existence of this equilibrium, not merely between the coloured areas but also between all the elements in the picture: simply look at it turned on its side or upside down. The balance is disturbed on each occasion and on each occasion a different kind of painting with a different dynamic presents itself.

It may be surprising that any picture containing so few elements should be capable of providing such a complicated visual experience. Two colours and eight lines combine to create an image which rewards lengthy examination and can be returned to in expectation of finding some new relationship between the various parts.

Mondrian painted scores of pictures which employ as few elements and many more which use even fewer. Each of them is different from the next, some dramatically so. If nothing else, these pictures demonstrate that a restricted visual language does not necessarily result in a restricted kind of visual experience. On the contrary, the richness of the experience provided by *Composition with Blue and Yellow* derives

essentially from the apparent poverty of the language it employs.

This lengthy description of Mondrian's painting is prosaic, even dull. This is because the experience the picture offers is so thoroughly visual that it cannot adequately be put into words. It is thoroughly but not entirely visual, however: feelings are also involved.

Firstly, there is a feeling akin to exhilaration caused by the near perfection of the poise, the balance that has been achieved. There is also a repeated sense of reassurance, even relief, caused by the recognition that all the elements combine in a way which resolves all potential conflict within them. The painting communicates peace and serenity.

If these assertions are doubted, take a piece of blank paper and place it over the illustration so as to obscure one or several of the elements in the painting. The balance and consequently the mood will be destroyed. The result is another picture, and another set of feelings emerges.

So far Mondrian's painting and some possible reactions to it have been described. Is this how the artist intended his picture to be seen? Is this question valid?

Mondrian wrote a great deal about his painting and tried to make his intentions plain. His writings show that his pictures in part resulted from complicated ideas which are concerned with religious, or at least spiritual, experiences.

Here is an extract from one of his most important essays, 'Natural Reality and Abstract Reality', which he published in 1919. He is discussing what he calls 'the new plastic idea' – the new reality which he wants his art to reveal.

It is not difficult to see how such phrases as 'balanced relations' refer to paintings such as *Composition with Blue and Yellow*. What Mondrian means by 'the essential and fundamental element in any plastic emotion of the beautiful' is by no means clear, however, and is matched by several other passages of equal opacity.

> The new plastic idea cannot, therefore, take the form of a natural or concrete representation, although the latter does always indicate the universal to a degree, or at least conceals it within. This new plastic idea will ignore the particulars of appearance, that is to say, natural form and color. On the contrary, it should find its expression in the abstraction of form and color, that is to say, in the straight line and the clearly defined primary color.
>
> These universal means of expression were discovered in modern painting by a logical and gradual progress toward ever more abstract form and color. Once the solution was discovered, there followed the exact representation of relations alone, that is to say, of the essential and fundamental element in any plastic emotion of the beautiful.
>
> The new plastic idea thus correctly represents actual aesthetic relationships. To the modern artist, it is a natural consequence of all

Mondrian's studio, Paris, c. 1931. This photograph makes clear that the studio was itself a kind of art work. The easel with a painting on it is placed directly in front of the wall so that the composition of the painting relates to the arrangement of coloured rectangles behind it. The atmosphere is clinical, more like a laboratory than the working space of an artist. In the bottom right-hand corner is Mondrian's gramophone which he had painted bright red. It, too, had to contribute to the design of the room and the mood it created.

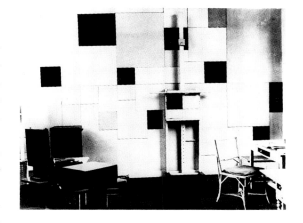

15

the plastic ideas of the past. This is particularly true of painting, which is the art least bound to contingencies. The picture can be a pure reflection of life in its deepest essence.

However, new plasticism is pure painting: the means of expression still are form and color, though these are completely interiorized; the straight line and flat color remain purely pictorial means of expression.

Although each art uses its own means of expression, all of them as a result of the progressive cultivation of the mind, tend to represent balanced relations with ever greater exactness. The balanced relation is the purest representation of universality, of the harmony and unity which are inherent characteristics of the mind.

If, then, we focus our attention on the balanced relation, we shall be able to see unity in natural things. However, there it appears under a veil. But even though we never find unity expressed exactly, we can unify every representation, in other words, the exact representation of unity can be expressed; it must be expressed, for it is not visible in concrete reality.

We find that in nature all relations are dominated by a single primordial relation, which is defined by the opposition of two extremes. Abstract plasticism represents this primordial relation in a precise manner by means of the two positions which form the right angle. This positional relation is the most balanced of all, since it expresses in a perfect harmony the relation between two extremes, and contains all other relations.

Anyone wishing to understand Mondrian's motivation and the effect on the viewer he wished to achieve would have to grapple with a large number of essays, some much more difficult than this. For the determined reader the reward is a fascinating, if not entirely credible, theory which embraces art and nature, indeed all reality.

Paintings such as *Composition with Blue and Yellow* seem as far removed from nature as they could possibly be. They consist of elements – primary colours, vertical and horizontal lines – which never occur in a pure form in the natural world. As his theories reveal, Mondrian viewed nature with distaste. Everything living tends to proliferate. In a garden each plant does its best to dominate all others. Each plant, moreover, is unique. While there are obvious similarities between species, no chrysanthemum leaf is identical to any other.

The bewildering number of natural forms and the continuous struggle between elements, species and individuals result, according to Mondrian, in a restless, confusing world in which people, equally various and equally determined to dominate, must feel ill at ease.

Mondrian also believed, however, that the world familiar to man is but one aspect of nature. It is its least pure and least satisfactory aspect, providing a highly distorted reflection of a higher reality, what, in our extract, Mondrian calls the 'unity in natural things' which 'appears under a

The Dutch landscape throws up striking relationships between verticals and horizontals, between the natural and the man made. Mondrian's artistic language may have been in part derived from his observation of such motifs as this.

veil'. That reality, never directly glimpsed, is ordered, exhibits at its most perfect a set of uniform principles which governs the external appearance of everything in nature. To glimpse that order behind the veil, however darkly, is to perceive the ultimate harmony of the universe and, as a human being, to be relieved of a destructive inner conflict.

Mondrian's primary colours, his vertical and horizontal lines, are, as the irreducible elements of painting, the pictorial equivalent of the fundamental, irreducible laws governing all of nature. The harmony Mondrian achieves when he combines them is analogous to the equilibrium of the universe itself.

Black and white are extreme opposites. So, too, are vertical and horizontal lines. Their reconciliation is symbolic of the reconciliation of opposing forces in nature, necessary if perfect happiness is to be achieved.

Mondrian's strange and difficult ideas may become easier to understand if it is remembered that he was Dutch. The landscape of Holland is perhaps the least natural on earth. The system of dykes and polders by which land is claimed and protected from the sea dramatically demonstrates the triumph of human reason over nature. Significantly, the system devised by the intellect employs regular geometric forms. The man-made Dutch landscape is dominated by vertical and horizontal lines.

Mondrian was brought up in the Calvinist tradition, the extreme Protestant faith which holds that the senses are a snare and a delusion. In a Calvinist church there are no decorations to delight the eye, no incense to beguile the nose and no music to seduce the ear. The focal point of the church is not an altar but the pulpit and lectern. Appeal is made to the intellect exclusively through the word, for the intellect is confused by the senses.

The apparent poverty of Mondrian's visual language is determined by similar, although by no means identical, beliefs. His paintings, looked at in the original, do appeal to the senses, especially through the sensuous quality of the paint itself. Entirely Calvinist, however, is the rigorous discipline, imposed in the belief that the greatest freedom exists at the point of the greatest restriction.

Mondrian modified his surroundings in accordance with this principle. He worked in a studio in which the walls, furniture, even the flowers in a vase on the table, were painted white. The only relief from the relentless monochrome was provided by a small number of squares in the primary colours fixed to the wall in carefully judged positions. The effect of the colour was enhanced by the monotony of everything else.

It is significant that Mondrian was a gifted and enthusiastic ballroom dancer whose preferred steps were those such as the foxtrot which demand the greatest discipline. Here, too, the more rigorous the rules, the greater the pleasure and the more acute the physical delight.

Knowledge of Mondrian the man and, however superficial, of his theories may not fundamentally change a person's attitude to a picture such as *Composition with Yellow and Blue* but it surely enriches it.

Diagram explaining the gentlemen's steps in the natural (or right) turn in the foxtrot. Mondrian loved dancing, jazz and music generally. He painted while listening to the gramophone and one of his most famous late abstract compositions is called *Broadway Boogie Woogie*.

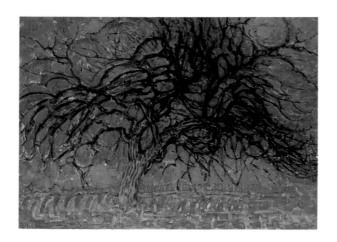

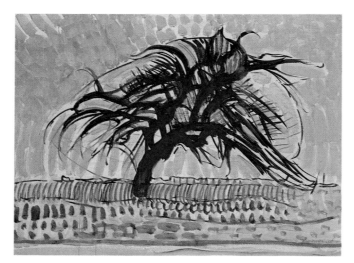

Top: Mondrian, *The Red Tree*, 1908
Centre: Mondrian, *The Blue Tree*, 1909–10
Bottom: Mondrian, *The Grey Tree*, 1912
Right: Mondrian, *Flowering Apple Tree, c.* 1912

By painting the same object repeatedly, Mondrian learned about its essential form and how to reduce it to what he thought were its fundamental elements. There are series of studies of, for example, a lighthouse, of a church façade and, most memorably, of a tree which, produced over a period of several years, explore the possibilities each object suggested for a treatment in terms of heightened colour as well as exaggerated form. The trees reproduced here do not constitute the entire series; but they do show the development in its most important stages. The first two with their brilliant colours and expressive, almost calligraphic, brushwork show that Mondrian was interested in Fauvism while the final pair, virtually monochrome and more restrained in handling, betray the influence of Cubism, the style created by Picasso and Braque which Mondrian studied while living in Paris before the First World War. The last is virtually an abstract composition. Seen on its own, its subject would not immediately be apparent. To begin with Mondrian worked exclusively from subjects taken from nature. Once he had arrived at a basic vocabulary of shapes and colours in the manner suggested by this series of illustrations, he was able to compose freely with no natural model in mind.

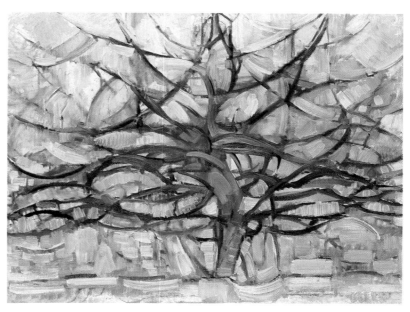

A theory may in part determine how an artist paints, but it can never provide the only motive. The pictures Mondrian was producing in the 1930s constitute one stage of a long and interesting development: theory and practice went hand in hand. Knowledge of Mondrian's development also enriches an understanding of *Composition with Yellow and Blue*

Like all artists of his generation, Mondrian began as a painter of nature. His early works are landscapes, increasingly dominated by single objects – a church tower, a lighthouse, a sand dune. These were progressively stripped down to their bare essentials so that in a series of paintings of, for example, a tree, what begins as a relatively accurate copy of the object itself ends by being a simplified statement about its essential structure. Mondrian has pared away the superficial characteristics to reveal the fundamentals. Similarly, in drawings of a church façade the windows, doors and buttresses are quickly reduced to a series of straight lines occasionally interrupted by a semicircle. The original subject is no

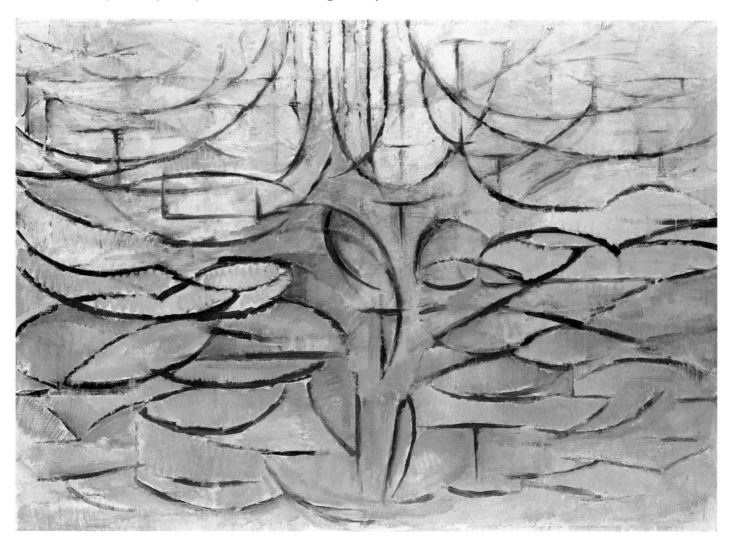

longer recognizable; only if earlier, more representational studies are known do such drawings make sense as descriptions of nature.

By the time Mondrian had arrived at a disciplined language of similar marks, the imitation of the appearance of things was no longer his aim. He was using the tree and the building as a source: he was abstracting, deriving his visual vocabulary from nature.

Once he had established the basic language, he was able to forget all external sources of imagery and construct his paintings without reference to the outside world, entirely, as it were, from his head.

To know something of Mondrian's development is no more essential to an understanding of his paintings than is a knowledge of Mondrian the man; but both greatly enhance such an understanding.

KLEE: PARK NEAR L(UCERNE)

Mondrian's picture makes no reference to the outside world. It is not reminiscent of anything (other than other paintings by the same artist). It is self-sufficient, an example of the purest kind of abstraction imaginable.

The little picture which the Swiss artist Paul Klee made a few years later employs a kind of abstraction that is much less pure. Instantly recognizable as a tree is the shape just above the centre of the composition. This persuades the viewer to see plants in all the other shapes with the exception of something at the bottom which looks like a man raising his arm. These assumptions are obviously right because the title of the picture is *Park near L(ucerne)*.

Klee's painting is not an abstraction in the sense that Mondrian's trees are abstractions. It is clear that he did not sit down in the park drawing simplified versions of what he saw in front of him. Paradoxically, the results might have looked less plant-like had he done so. The shapes are less abstractions than ideograms, short-hand characterizations which sprang from Klee's imagination with the aid of memories of all the plants he had ever seen.

The shapes, all of them created from simple, heavy black lines, have something of the naivety of children's drawings about them. That, too, is intentional. A picture made by a young child invariably evokes innocent pleasure, delight in the discovery of an as yet unfamiliar world and genuine happiness. By alluding to the look of such art, Klee introduces an optimistic atmosphere into a painting which is far from naive or unsophisticated. Like Mondrian, Klee employs a visual language to evoke feelings, although he does so in a very different way.

This painting not only expresses something of the innocent pleasure of a child playing in a park. It also suggests something exotic and lush, quite at variance with the European location of its title. A knowledge of Mondrian's personality and artistic development enriches an understanding of everything he ever produced. The same is true of Klee's work, although not to the same extent, since his development was by no means as logical or as consistent as Mondrian's.

Nevertheless, one possible source of the exotic atmosphere of

Klee's painting (opposite) is clearly far more sophisticated than the picture by a six-year-old boy, yet both employ simplified, ideographic imagery to capture the essentials of the subject.

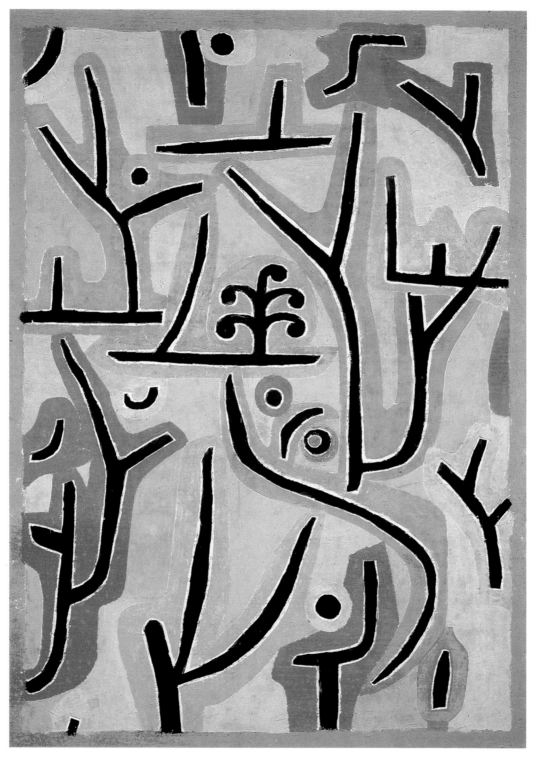

Paul Klee (1879–1940), *Park near L(ucerne)*, 1938.

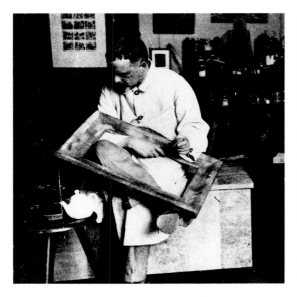

Klee in his studio at the Weimar Bauhaus. He would work concurrently on several pictures and loved to experiment with a wide variety of techniques and media. His studio was a private place. A teaching colleague remembered that there were so many potions in bottles standing around in Klee's studio that it looked like an alchemist's lair.

Park near L(ucerne) is suggested by the fact that Klee had travelled in North Africa and was fascinated by Arabic script and Islamic art. Marks reminiscent of Arabic writing form the basis of several of Klee's pictures, and they directly relate to the plant-like forms in this painting. We sense the relationship dimly, even if we are ignorant of the other work and of the artist's travels in Egypt and Tunisia.

The script of any language is a form of abstraction. The shape of the letter 'A' is essentially arbitrary and related to its specific meaning as a sound only by history and habit. The same is partially true of a Chinese pictogram, although it is an abstraction in a more obvious sense. The symbol for 'mountain', for example, is obviously derived from a stenographic paraphrase of a row of mountain peaks, while that for 'river' is a simple stylization of water in movement.

In Islamic culture all representational art is forbidden because only God is considered qualified to create such images. Islamic art therefore consists exclusively of abstraction: Arabic script, which combines to

produce words and therefore to evoke things and concepts, is used as the basis of an extraordinarily imaginative and rich variety of decoration.

Of course it is not possible to 'read' Klee's 'writing': he only alludes to the forms of Arabic script in order to create exotic associations. The colours of *Park near L(ucerne)* reinforce these associations. Always forming clear shapes which echo the black lines which they surround, these colours are flat and, apart from the warm orange around the 'tree', are cool. They help to make the entire picture look like a mosaic of irregular tiles, like an Islamic mosaic, in fact, an appearance strengthened by the addition of a coloured border which encloses the whole painting.

In spite of the allusions to nature in the simplified plant forms, Klee's picture is not an abstraction from nature; but it is obviously much closer to nature than Mondrian's rigorous geometry.

Like Mondrian, Klee developed complex and detailed theories not only about his own art but also about art in general. Although they are often difficult to follow, they are enlivened by vivid descriptions and, as

22

we might expect from the author of *Park near L(ucerne)*, by repeated allusions to nature. In his 'Creative Credo' of 1920, for example, Klee describes the making of (and therefore the experience of looking at) an abstract drawing.

Islamic art was 'rediscovered' by European artists – Matisse and Klee among them – before the First World War. Although Klee travelled to North Africa in 1914, he did not introduce elements and colours alluding to Islamic art into his own work until some time later.

> *Let us develop this idea, let us take a little trip into the land of deeper insight, following a topographic plan. The dead center being the point, our first dynamic act will be the line. After a short time, we shall stop to catch our breath (the broken line, or the line articulated by several stops). I look back to see how far we have come (counter-movement). Ponder the distance thus far traveled (sheaf of lines). A river may obstruct our progress: we use a boat (wavy line). Further on there might be a bridge (series of curves). On the other bank we encounter someone who, like us, wishes to deepen his insight. At first we joyfully travel together (convergence), but gradually differences arise (two lines drawn independently of each other). Each party shows some excitement (expression, dynamism, emotional quality of the line).*
>
> *We cross an unplowed field (a plane traversed by lines), then thick woods. One of us loses his way, explores, and on one occasion even goes through the motions of a hound following a scent. Nor am I entirely sure of myself: there is another river, and fog rises above it (spatial element). But then the view is clear again.*

23

Basket-weavers return home with their cart (the wheel). Among them is a child with bright curls (corkscrew movement). Later it becomes sultry and dark (spatial element). There is a flash of lightning on the horizon (zigzag line), though we can still see stars overhead (scattered dots). Soon we reach our first quarters. Before falling asleep, we recall a number of things, for even so little a trip has left many impressions – lines of the most various kinds, spots, dabs, smooth planes, dotted planes, lined planes, wavy lines, obstructed and articulated movement, counter-movement, plaitings, weavings, bricklike elements, scalelike elements, simple and polyphonic motifs, lines that fade and lines that gain strength (dynamism), the joyful harmony of the first stretch, followed by inhibitions, nervousness! Repressed anxieties, alternating with moments of optimism caused by a breath of air. Before the storm, sudden assault by horseflies! The fury, the killing. The happy ending serves as a guiding thread even in the dark woods. The flashes of lightning made us think of a fever chart, of a sick child long ago.

By reading Klee's theories, it is discovered that he believed the making of art to be analogous to natural creation. Just as a tree, drawing nourishment through its roots from the soil and through its leaves from the sun and air, grows in a way determined by its environment, so, too, does the artist create objects. The appearance of the objects is determined by his personality, which is shaped by his surroundings.

For Klee each picture had to grow naturally, one form producing the next until, like a self-sufficient organism, it appeared to have independent life and was therefore finished. A conventional landscape painter imitates the surface appearance of nature. His aim is to produce a picture which creates the illusion of reality. Klee's aim was more ambitious: he wanted not to create an illusion but to reveal an aspect of reality itself. He wanted to find parallels in art for the way nature works at the deepest level. Paradoxically, therefore, Klee intended his pictures, however abstract they might seem, to be more real in terms of what

A diagram from Klee's teaching manual, *The Pedagogical Sketchbook*, 1925, to illustrate the relationship between forces and the result of their interaction. The active current of the water drives the wheels to work the passive hammer. Klee was fond of drawing such analogies as an aid to understanding the relationship between the various parts of a painting and the functioning of pictorial imagery.

24

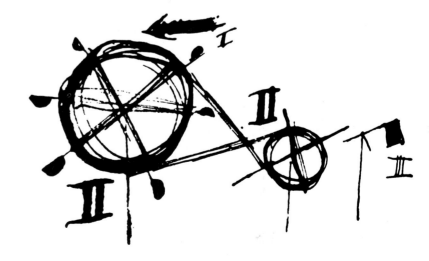

they tell us about nature than any painting which convincingly imitates the look of a landscape or person. As he put it himself in the 'Creative Credo': 'Formerly we used to represent things visible on earth, things we either liked to look at or would have liked to see. Today we reveal the reality that is behind visible things, thus expressing the belief that the visible world is merely an isolated case in relation to the universe and that there are many more other, latent realities.'

In spite of first impressions, neither the picture by Mondrian nor the one by Klee is decoration, concerned only with pattern. There is far more to each than the arrangement of colours, lines and shapes to create a pleasing effect. Each evokes feelings, stimulates the mind and affects the mood. More importantly, each poses questions about the nature of reality. Both Mondrian and Klee wish to demonstrate that there is far more to reality than what the eye sees.

As has been said, *Park Near L(ucerne)* is not an abstraction from nature. Shapes and colours are conceived and arranged in a way which evokes nature. Because nature is alluded to rather than precisely described, Klee's imagery can be ambiguous; it can mean several things at once. It can remind the viewer simultaneously of vegetation, Islamic art and a child's painting. The greater the viewer's store of visual memories, the more allusions he will find in the picture and the richer Klee's imagery will seem.

Because Klee's picture repeatedly alludes to the outside world, it is less abstract than Mondrian's composition, which is totally self-sufficient, devoid of any representational element. Nevertheless, abstract paintings

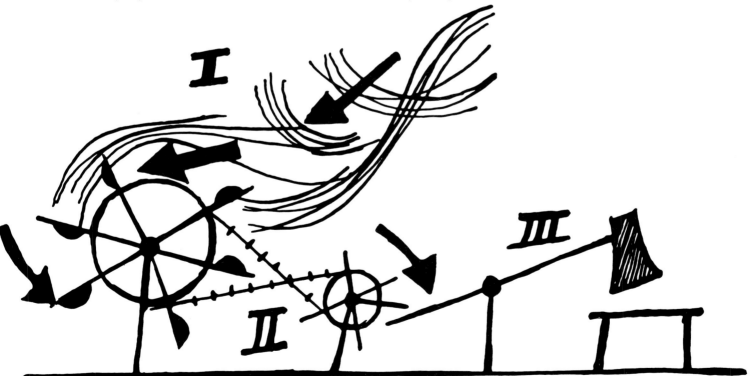

Photograph of Kandinsky. Kandinsky's appearance did not fit the conventional picture of the artist. He invariably wore a dark suit, wing-collar and tie and gave the impression of being a scientist or businessman. His students at the Bauhaus found him intimidating.

can be more or less abstract, depending on the way in which they were executed and the kind of imagery they employ.

KANDINSKY: IMPROVISATION NO. 30

The painting *Improvisation No. 30* dates from 1913 and is several years earlier than either the Klee or the Mondrian. It is the work of Wassily Kandinsky, a Russian then living in Germany, and at first sight it looks like an abstract composition, albeit of a kind different to anything encountered in this book so far. Because of its irregular shapes and its loose composition, it is closer to the Klee than to the Mondrian, however.

If first sight is followed by longer consideration, what seemed to be an energetic arrangement of rhythmic lines and dramatic colours begins to assume a coherent form: the abstractions turn out to represent something. To begin with, the lines and irregular areas of colour suggest a landscape dominated by a mountain or some other prominent physical feature in the centre of the picture. Buildings – high towers with windows in them – can also be seen. Most easily recognizable, though, is the double-barrelled cannon with wheels in the bottom right-hand corner. It has just been fired and the smoke from the shells billows over towards a group of people, apparently armed with lances, on the left. *Improvisation No. 30* is, in short, a battle picture.

Kandinsky's painting is obviously an abstraction which retains traces of the scene it was abstracted from. The scene existed not in nature but inside the artist's head. Earlier in his career, Kandinsky painted many representational scenes taken from his imagination. He might have chosen to paint this battle more representationally, but he did not. Why? Did he lack the skills necessary for the task?

That Kandinsky was able to paint representational scenes and create convincing illusions of reality is demonstrated by his earlier work. He made a conscious decision to treat his battle scene in this way and, significantly, he chose to give his picture an official title which gives no clue to its partially hidden content. Privately, he called it *Cannons*, but he made it clear that, in his view, the true content of the work had nothing to do with cannons or anything else representational.

> *These contents are indeed what the spectator* lives *or* feels *while under the effect of the* form and colour combinations *of the picture. This picture is nearly in the shape of a cross. The centre – somewhat below the middle – is formed by a large, irregular blue plane. (The blue colour in itself counteracts the impression caused by the cannons!) Below this centre there is a muddy-grey, ragged second centre almost equal in importance to the first one. The four centres extending the oblique cross into the corners of the picture are heavier than the two centres, especially heavier than the first, and they vary from each other in characteristics, in lines, contours, and colours.*
>
> *Thus the picture becomes lighter or looser in the centre, and*

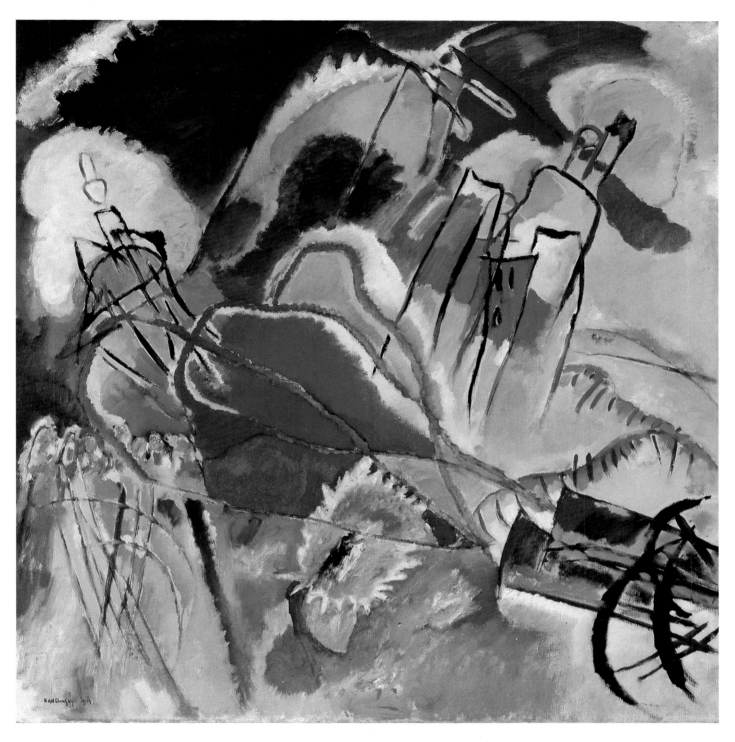

Wassily Kandinsky (1866–1944), *Improvisation No. 30,*
1913.

Kandinsky, *Amsterdam, View from the Window*, 1904.

heavier or tighter towards the corners. The scheme of the construction is thus toned down, even made invisible for many, by the looseness of the forms. Larger or smaller remains of objectivity (the cannons for instance) produce in the spectator the secondary tone which objects call forth in all who feel.

As one of the earliest abstract painters, and also one of the first to attempt to explain what he was doing and why he was doing it, Kandinsky is an important figure. Much will be said about him later, and about the relationship between paintings such as this and his theories. What must be acknowledged immediately is that his intentions are not entirely fulfilled by this painting: it is difficult not to see a cannon in it and thereafter not to see the whole composition as a battle scene.

Admittedly, Kandinsky goes on to say in his explanation of *Improvisation No. 30* that the viewer must learn to look in the correct way at his painting, implying that habits acquired from looking at representational art must be discarded before the point of an abstract work can be grasped; but the fact is that the temptation to see an image even in the vaguest blob is irresistible. An infant will react to a

Photograph of Cumulonimbus clouds in a formation resembling a snail.

28

crudely drawn circle in the way it does to the face of its mother. It is virtually impossible to look at a cloudy sky without seeing a succession of images and perhaps even recognizing animals in the constantly changing forms.

The distance between intention and result in Kandinsky's picture illustrates the problems faced by any artist who is determined to make a non-representational picture. The universal urge to make sense of everything by relating it to familiar aspects of the familiar world is so strong that it is exceedingly difficult to make a truly abstract image. Mondrian succeeded by turning his back on natural forms entirely. Klee preferred to exploit the viewer's desire to discern images in everything and wittily plays with the process of puzzlement and recognition. Kandinsky believed that he could move so far away from a representa-

Left to right: Kandinsky, his wife Nina, and teaching colleagues Georg Muche, Paul Klee and Walter Gropius. Gropius was the founder and first director of the Bauhaus where this photograph was taken in 1926.

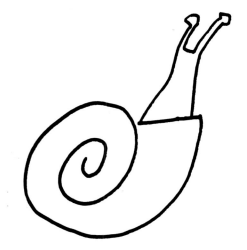

tional starting point that the underlying images would no longer be recognizable. He did eventually succeed.

MATISSE: THE SNAIL

Kandinsky gave his painting a nondescript title in order to obscure still further the partly hidden imagery from which the composition had evolved. Almost exactly forty years later the French painter Henri Matisse gave a precisely descriptive title to what seems to be a totally abstract composition. Try as the viewer might he will fail to discern anything familiar in Matisse's *The Snail.*

Perhaps the arrangement of the shapes around the centre is reminiscent of the spiral form of a snail's shell, but it is impossible to see a snail or any other living or natural thing in this picture. That, in itself, is something of an achievement, although it was certainly not Matisse's main aim in making this composition. What he wanted to do was make a pleasing arrangement of a number of coloured shapes.

Who can deny that Matisse succeeded? Even in reproduction the picture is arresting (it is difficult to take one's eyes off it), handsome, beautiful, delightful and charming. Such words imply that *The Snail* evokes a mood, and so it does. It is warm, happy and contented; it is joyous.

Although the composition consists of no more than twelve elements (eleven irregular rectangles and the ragged 'frame'), the visual effect of the arrangement is complex. None of the shapes has quite the same colour as another; even the 'frame' shifts subtly from one tone of orange to another.

Mondrian's abstraction was the result of a deeply serious, almost religious, philosophy. Its aims are weighty. Is it enough for any picture to evoke pleasant moods by means of pleasing arrangements of shapes and colours? Are Matisse's aims any less worthy of attention than Mondrian's? The answer to that is a vehement 'no'. To give pleasure is surely an admirable aim in any activity. All too often attempted, it is all too rarely achieved. Another, related question is less easy to answer: what is the difference between Matisse's picture and a section of patterned wallpaper or the design on a necktie or headscarf? All of them are, after all, intended to be visually pleasing.

The Snail would indeed make a beautiful headscarf, although its suitability as a design for a tie or a wall-covering is considerably less obvious. But why should there be any difference between an abstract painting and the decoration on an object for use? Why can we accept abstraction in one context (wallpaper, textiles) but not in another (painting)?

An important part of the effect of the picture is its scale, and also the technique Matisse used to make it. Almost 10 feet (3 metres) square, it is a huge composition, and the sheer size of the shapes greatly enhances the effect of the colour and emphasizes the rhythms suggested by the disposition of the shapes.

It is not a true painting. It consists of pieces of paper that have been

Abstract pattern English wallpaper, 1920–30.

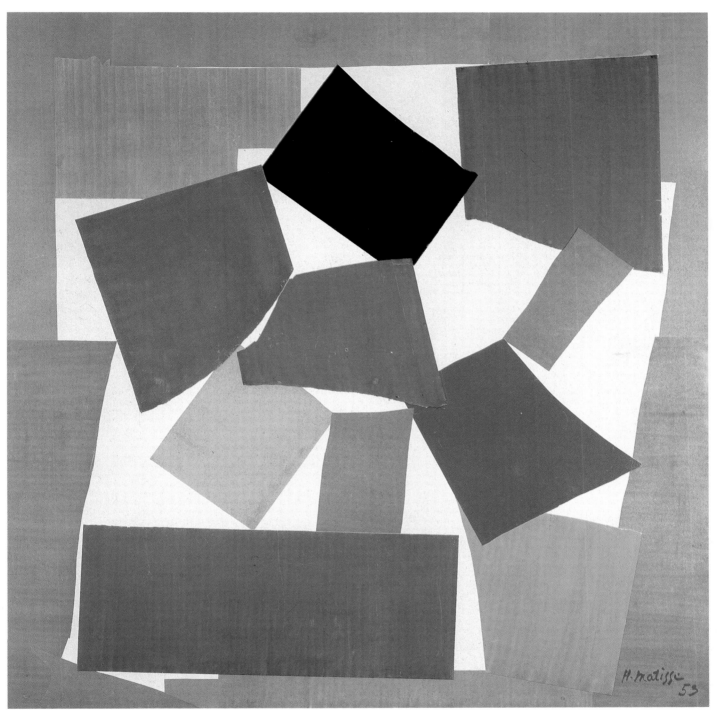

Henri Matisse (1869–1954), *The Snail*, 1953.

Matisse sketching in his studio, a photograph by Brassai, c. 1930.

cut from larger pieces that were painted in advance. Matisse could shift them around before arriving at what he felt was the most pleasing arrangement, and he could then fix them in place with glue. This technique explains the uniformity and flatness of the colours and the clean sharpness of the edges of the shapes, all of which contribute to the effect of *The Snail* and none of which could be achieved by conventional methods of painting.

By the time Matisse made *The Snail* he was too ill to use brushes. Confined to a wheelchair, finding all movement difficult, his hands virtually crippled, he managed only to cut the shapes he needed, place them and stick them down with assistance. But the method was more than a compromise determined by physical disability. It enabled Matisse to use pure colour more directly than he had previously done. As he himself put it: 'The paper cut-out allows me to draw in colour. It is a simplification for me. Instead of drawing the outline and putting the colour inside it – the one modifying the other – I draw straight into the colour.'

Of course Matisse did not set out with a clear idea of how *The Snail* would look. He almost certainly had no idea of the title, either. He began by placing a single coloured shape on the huge white square. A second followed and then a third. Their placing would then be changed. They would be shifted this way and that until Matisse achieved an effect which satisfied him. Sometimes, no doubt, a shape would be re-cut or discarded.

Matisse was improvising, allowing the progress of his picture to be determined in part by actually making it. Artists have, of course, always improvised, and most of them are eager to exploit the result of a happy accident. Modern artists are different, however, because they are prepared to induce accidents and exploit their results as part of their creative method. Matisse was not as extreme in this respect as Hans Arp, who once made a picture by randomly dropping a number of coloured rectangles and fixing them where they fell, but Matisse did recognize that chance is capable of producing effects more surprising than anything suggested by conventional means.

Matisse had always been a superb colourist but he had by no means always been an abstract artist. Not until he started to work with cut coloured paper late in his life did he move away from representation, and even then only from time to time: the majority of his cut-paper compositions are highly decorative but clearly refer to the natural world.

Mondrian and Kandinsky maintained that there are enormous, irreconcilable differences between figuration and abstraction. They could never have worked in both ways at the same time. For Matisse, however, there was no essential difference. As he himself said, 'Nature is always present' whether or not it is instantly recognizable as such. All his work – paintings, drawings, collages and sculptures – abstract and figurative, is about the same delight in visible things, the same sensuous pleasure. Something he said in 1908 is valid of *The Snail*, which he made

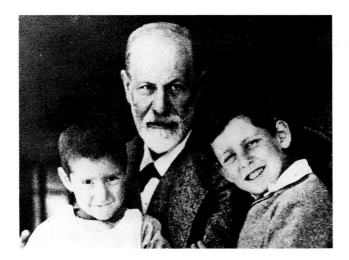

The founder of psychoanalysis Sigmund Freud with two of his grandchildren, 1920. Freud's theory of the unconscious has had an incalculable effect on twentieth-century art.

in the penultimate year of his life almost half a century later: 'What I dream of is an art of balance, of purity and serenity devoid of troubling or disturbing subject-matter… like a comforting influence, a mental balm – something like a good armchair in which one rests from physical fatigue'.

To many modern artists, no matter how powerful their imaginations, chance seemed infinitely more resourceful and productive, a more creative tool than anything deliberate, willed. This belief was the result of a widespread modern conviction that the major part of the human mind lies submerged beneath normal consciousness, and that the human personality is largely irrational and incalculable. Significantly, the role of chance in art grew with the influence of Freud's psychoanalysis and partly as a result of it. Indeed, Freud and his disciples often used techniques exploiting chance to penetrate the subconscious minds of their patients.

POLLOCK: ALCHEMY

In *The Snail* Matisse employed chance in a minor way and under highly controlled conditions. In the kind of abstract painting represented by Jackson Pollock's *Alchemy*, accident is at the very centre of the creative method.

It is a large painting but it is not the size of the Pollock alone which makes illustration difficult. The painting consists of a network of marks so dense and varied that they can only be properly perceived in the original.

Even in the presence of the original many people find it difficult to experience anything but bewilderment, dismay and annoyance. *Alchemy* looks less like the work of a serious artist than the result of a frenzied attack on the canvas by an enraged drunkard. Another comparison suggests itself: a sheet used over a period of time by a decorator to protect the furniture in the room he is painting.

It is possible to see *Alchemy* in another, more positive way, however; to allow it to provide a complex and satisfying visual experience. If looked at for long enough, the seemingly random and

Over: Jackson Pollock (1912–56), *Alchemy*, 1947.

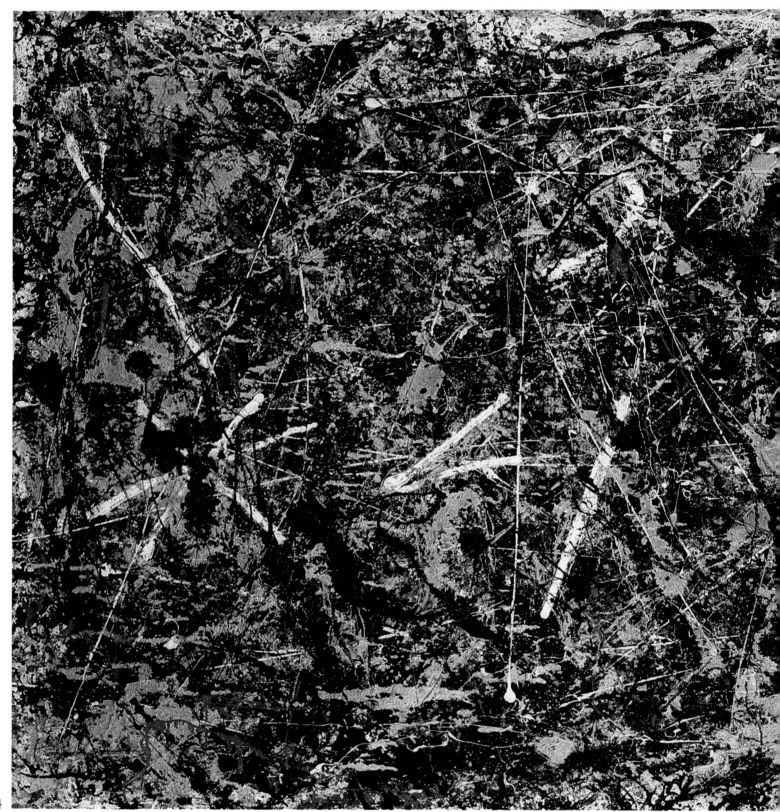

34

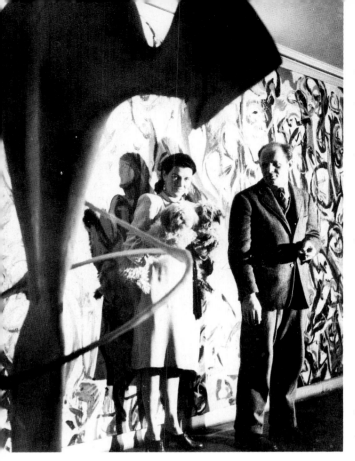

Pollock with one of his earliest patrons, Peggy Guggenheim, standing in front of one of his compositions.

chaotic marks assume a coherent structure, or rather a series of structures which appear to exist at different levels in space. Moreover, the energy with which the paint was applied evokes a sense of movement and drama.

So purely visual is the experience of looking at Pollock's painting that it is almost impossible to describe. The illusion of space is repeatedly complicated by areas of background which break through: now one area lies on the surface, a linear web with patterns inside it, each pattern different. Now it recedes into infinite space.

The method employed by Matisse in *The Snail* involved improvisation: when he began he had no clear idea of how the final picture would look, and he proceeded by trial and error, adjusting one shape to the next until he felt ready to glue all the parts down. Pollock's painting is the result of an even greater degree of improvisation and of an even less orthodox technique.

Alchemy was not painted with brushes or palette knives while supported by an easel. Pollock took a large sheet of canvas which he pinned to the floor. Using paint squeezed from tubes and kept in tins and buckets, and applied with sticks and twigs, he splattered, dribbled and spilled paint directly on to the canvas from above. Layer followed layer, the appearance of each mark determined by the movement of the arm or body, by the speed and energy of the movement and by the distance of the arm from the floor.

The process sounds like a series of intentional accidents and in a sense that is what it was. Certainly each mark suggested how the next might look and certainly Pollock had a high degree of control over what he was doing.

It is significant that the painting seems to bear the marks of its

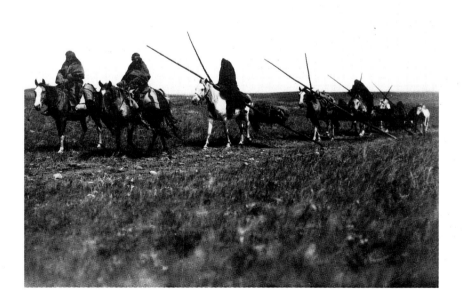

Indians on Horseback, a photograph by Edward Curtis. The landscape of the American West, and especially its space and grandeur, finds an echo in Pollock's work.

making so clearly. If such a work can be said to have a subject, it is in part the record of how it was made.

The Dutch landscape adds to an understanding of Mondrian's art. Pollock was born in Wyoming and the landscape of the American West, the sense of limitless space and of the grandeur of scale it provides, adds to the understanding of paintings such as *Alchemy*. Unlike Mondrian, however, Pollock did not care for theory and said very little about his aims and ideas. Where the artist was reserved, the critics were forward. If he preferred to make the occasional statement and then hold his peace, they fell over themselves to explain, interpret and justify.

Just as it is difficult to look at a Cubist painting without thinking of the words of Apollinaire, the first gifted critic to write about that difficult style, so is it difficult to look at Pollock without thinking of Harold Rosenberg, the first American critic to provide a convincing explanation of what Pollock and painters like him were doing and why it was important. It was Rosenberg who described the style as 'Action Painting' and who pointed to the importance of improvisation:

> At a certain moment the canvas began to appear to one American painter after another as an arena in which to act – rather than as a space in which to reproduce, re-design, analyze, or "express" an object, actual or imagined. What was to go on the canvas was not a picture but an event.
>
> The painter no longer approached his easel with an image in his mind; he went up to it with material in his hand to do something to that other piece of material in front of him. The image would be the result of this encounter.
>
> It is pointless to argue that Rembrandt or Michelangelo worked in the same way. You don't get Lucrece with a dagger out of staining a piece of cloth or spontaneously putting forms into motion upon it. She had to exist some place else before she got on the canvas, and paint was Rembrandt's means for bringing her there, though, of course, a means that would change her by the time she arrived. Now, everything must have been in the tubes, in the painter's muscles, and in the cream-colored sea into which he dives. If Lucrece should come out she will be among us for the first time – a surprise. To the painter she must be a surprise. In this mood there is no point to an act if you already know what it contains.

All conventional painting, whether figurative or abstract, is composed so that the eye is led around it in a particular way. It is persuaded to enter the picture at a certain point, to explore it along a pre-arranged path and at a speed which varies in a calculated fashion. This is as true of the Klee illustrated here as it is of the Kandinsky. They, like the Mondrian and the Matisse, have areas of diverse size, colour, texture and so on, which are ultimately brought to a state of balance.

None of this is true of the Pollock. It confronts the viewer like a

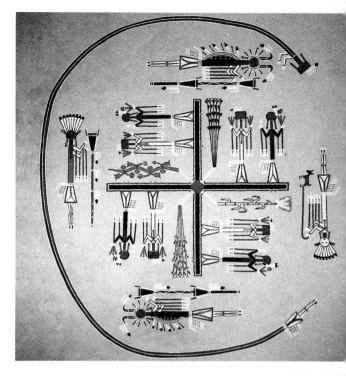

Sand painting executed by a Navajo Indian.

Paul Newman playing an Abstract Expressionist painter with decidedly unconventional methods in a scene from the film *What a way to Go*, 1969.

37

wall. It is not conventionally composed. It does not have a beginning, a middle and an end. It is, moreover, so large that the viewer cannot establish anything like that usual relationship with a painting in which he is the active, dominant participant. The Pollock overwhelms the field of vision (it is impossible to take it all in at a single glance) and presents a surface so complex that it can never be perceived or comprehended all together.

A perfectly legitimate question posed by such a description of what is new in Pollock's painting is: so what? By the time Pollock came to develop his dramatically original style, many painters aimed at novel effects and developed their styles partly out of a desire to do something that had never been done before. The ways in which their work could be said to be innovative, to set historical precedents, were as important as purely aesthetic or any other qualities.

There is, it might jokingly be said, nothing new about originality. It is in part the exhilarating sense of newness which distinguished Giotto's work in the fourteenth century, as it distinguished Caravaggio's in the seventeeth and Turner's in the nineteenth. It is the freshness and excitement which result from the attempt to grapple with problems that were then new which usually makes the work of such masters preferable to that of their many followers and imitators. Art is not like technology: the prototype is usually better than the production models. One of the factors which sets apart the art of the twentieth century from that of previous periods, however, is the enormous importance given by artists to originality relative to the other qualities – technical skill or imaginative power for instance – a work of art might possess.

Alchemy is one of the most exciting of all Pollock's paintings because the artist's improvisatory method was manifestly accompanied by an acute aesthetic sense and control. Where Pollock's so-called 'drip paintings' lack that control, that loose organization, they can be too bewildering. There are many examples of that kind of unsuccessful picture.

SCHWITTERS: OF SOUTH AFRICA

Pollock abandoned the conventional use of palette and brushes. There are those who would say that he also abandoned all traditional skills – if he ever possessed them. The German artist Kurt Schwitters, who was responsible for the picture with the curious title *Of South Africa*, seems at first sight to have abandoned both traditional skills and media. Schwitters's picture consists entirely of scraps of printed and coloured paper stuck down apparently at random. What is more, the paper seems to have been little better than rubbish: pieces of ripped advertisements, labels and torn receipts or bills.

By 1937–38, the date of *Of South Africa*, Schwitters had already been making pictures like this for almost two decades, sometimes also employing solid objects such as bicycle wheels, strips of metal and lengths of string in his compositions. Part of his purpose was to demonstrate that

38 Kurt Schwitters (1887–1948), *Of South Africa*, 1937–38.

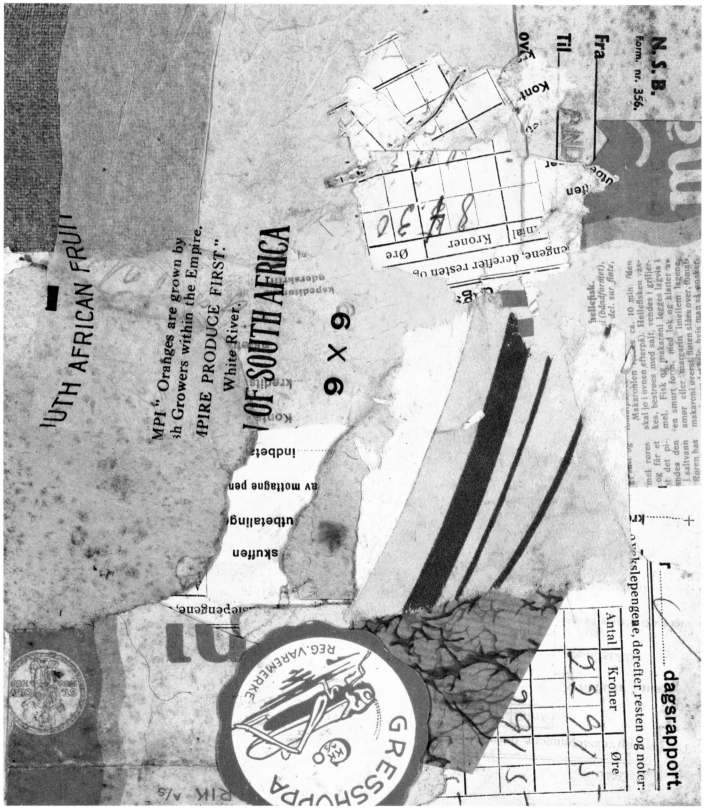

39

Portrait of Schwitters.

a picture did not have to be painted or drawn to be a picture. He recognized and, more importantly, wanted to reveal the inherent beauty of neglected and despised materials – the detritus of everyday life.

Certainly the grasshopper trade-mark is charming, and additional interest lies in the autobiographical hints provided by much of the paper. These are Schwitters's own bills, the orange paper presumably from a fruit he had eaten and the produce of South Africa to which the title refers. In spite of the unusual nature of the material, however, the picture is little different from an abstract composition produced by conventional means. The colours, tones and textures were not applied with a brush but they are a physical part of the materials themselves. The composition has been arrived at by careful juxtaposition of shape, colour and texture.

Schwitters's picture is, in fact, an extremely subtle aesthetic exercise in which actual texture, printed pattern and fragments of text are employed in precisely the way that a painter exploits transparency,

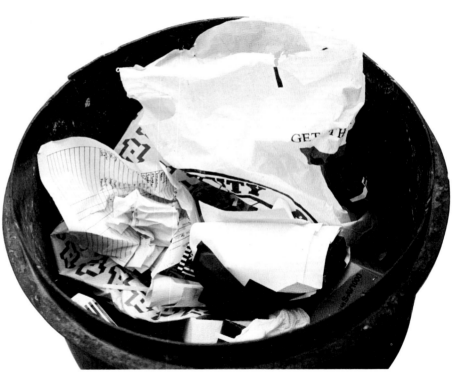

Schwitters employed all manner of rubbish in his collages, combining pieces of paper, coloured, textured and bearing a variety of texts, to make compositions of haunting beauty.

opaqueness and consistency in order to vary the surface of his composition, whether abstract or not.

Of South Africa directs the mind and eye towards areas quite different from a conventional painting. Real life in the form of rehabilitated rubbish has invaded art and the result is to persuade the viewer to look in a new way at what he previously overlooked, to discover visual excitement in things which he had never properly seen before.

Schwitters wanted his collages to do more than reveal previously

neglected sources of visual interest and excitement, however. He wanted them to be a vehicle for expression and shared the belief with all other abstract artists that representation interferes with and weakens expression. What Schwitters thought his abstract collages expressed is difficult to discover.

> *Every line, color, form has a definite expression. Every combination of lines, colors, forms has a definite expression. Expression can be given only to a particular structure, it cannot be translated. The expression of a picture cannot be put into words, any more than the expression of a word, such as the word "and" for example, can be painted.*
>
> *Nevertheless, the expression of a picture is so essential that it is worth while to strive for it consistently. Any desire to reproduce natural forms limits one's force and consistency in working out an expression. I abandoned all reproduction of natural elements and painted only with pictorial elements. These are my abstractions. I adjusted the elements of the picture to one another, just as I had formerly done at the academy, yet not for the purpose of reproducing nature but with a view to expression.*
>
> *Today the striving for expression in a work of art also seems to me injurious to art. Art is a primordial concept, exalted as the godhead, inexplicable as life, indefinable and without purpose. The work of art comes into being through artistic evaluation of its elements. I know only how I make it, I know only my medium, of which I partake, to what end I know not.*
>
> *The medium is as unimportant as I myself. Essential is only the forming. Because the medium is unimportant, I take any material whatsoever if the picture demands it. When I adjust materials of different kinds to one another, I have taken a step in advance of mere oil painting, for in addition to playing off color against color, line against line, form against form, etc., I play off material against material, for example wood against sackcloth.*

Conventional skills and conventional materials are crucial only in art that is itself conventional. Indeed, for an artist determined to be original, conventions of every kind are a potential hindrance. It is not even necessary for an artist physically to have made an art work in order that he might claim it as his own.

The most famous anecdote to illustrate that point concerns the Hungarian painter Laszlo Moholy-Nagy, who in Berlin in 1921 designed three paintings, each an abstract geometric composition, on graph paper and then described the designs over the telephone to a maker of enamel signs. When the craftsman had carried out the instructions Moholy collected them and with every justification exhibited them as his own work. In the extent of its deliberation and planning it was, of course, a method totally different from that employed by Jackson Pollock but in

the manner of their making the 'paintings' were even less conventional than anything by Schwitters.

RILEY: CATARACT 3

Many artists use not enamel sign-makers but assistants, a practice which dates back to the apprenticeship system of the Middle Ages and later enabled Rubens (to name just one painter to rely on scores of assistants) to produce so much work on such a scale. The practice continues in a reduced and altered form in some quarters today. The English painter Bridget Riley, conceives her compositions in gouache on graph paper and they are then painted full scale on canvas by assistants. One of the works produced in this way is *Cataract 3*.

There is often some doubt about an artist's precise intentions in making a specific work – even when the artist has tried to explain them in words. There can be no doubt about Riley's intentions here or about the success with which she has realized them. The illusion of rippling movement and distortion is so strong that the viewer cannot easily look even at a reproduction for very long. Faced with the huge painting in the original – it is more than 6 feet (1.8 metres) square – the power of the illusion has an almost physical effect, in some people akin to sea-sickness. Indeed, Riley's assistants can only work on small sections at a time, covering up what they have completed as they proceed, and some of them reputedly need to wear sunglasses.

All representational art is about illusion and some representational art is concerned with suggesting movement. Only an abstract painting can create such a strong illusion of movement, however, because the optical tricks on which they depend are geometric and regular.

An optical illusion tricks the eye: it is aggressive and seeks to dominate. *Cataract 3* and almost all of the paintings like it make most people feel uncomfortable. That is not Riley's intention. In her view it is

Riley at work in her London studio in 1984.

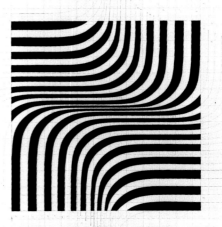

An untitled study by Riley showing the mathematical precision with which she produces the effects in the larger completed compositions.

42

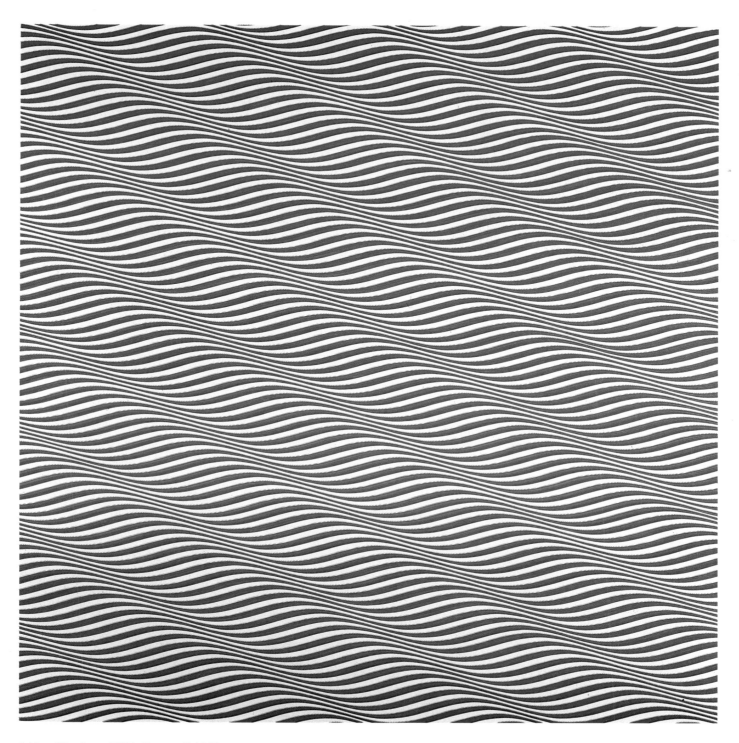

Bridget Riley (born 1931), *Cataract 3*, 1967

Miró, at an exhibition of the work of Matisse.

the result of the viewer's eyes having become lazy and complacent. She wants her work to have an invigorating, refreshing effect by exercising the eye and brain.

Whatever the viewer's reaction to *Cataract 3*, it clearly stands at the opposite pole to a Jackson Pollock in terms of method. Pollock improvised: his paintings evolved while he was making them. Riley plans each work down to the tiniest detail, making calculations on graph paper, making precise mixtures of paint. The greater her precision, the more certain she is of the success of the illusion.

It might be thought that Riley's art, by concentrating on the almost physical response of the eye, is limited because, unlike all the other examples of abstraction discussed here, it takes no account of the imagination and feelings. Riley herself would no doubt reject this suggestion by stating that the act of perception involves the same neurological events as the emotions. In any case, a work of art must not necessarily involve the feelings or the imagination in order to succeed.

MIRÓ: TIC TIC

Tic Tic by the Spaniard Joan Miró is a small painting of a quite different kind to the Riley. The words 'Tic Tic', together with some coloured spots and curious images of an indeterminate kind, float against a background of the most marvellous blue. Hardly anyone could fail to respond to this blue, the beauty of which, enhanced by the brightly coloured spots, is part of the painting's subject, suggesting as it does the velvet blue of the sky on a magical summer's night.

The arrangement of the spots and other shapes may seem arbitrary, accidental, but the painting turns out to be as carefully composed in its own way as the Riley. Jim Ede, who used to own *Tic Tic*, wrote: 'If I put my finger over the spot at the top right, all the rest of the picture slid into the left-hand bottom corner. If I covered the one at the bottom, horizontal lines appeared, and if somehow I could take out the tiny red spot in the middle everything flew to the edges.'

The way in which Miró composed this picture was clearly different to Riley's method, but akin to Pollock's. Organic, irregular shapes and signs cannot be ordered mathematically. Miró's placings were intuitive and cumulative. Accident played its part. The position of each mark and shape was determined by what was already there.

Miró's images, although not identifiable, look as though they ought to be. Like amoebae viewed through a microscope, they appear to have life. Most of the strange, often bizarre, creatures which occur in Miró's paintings were indeed derived from living things and are therefore abstractions; but their precise appearance was the result more of accident than design.

Miró believed that the most interesting parts of the imagination are usually closed off by logic and reason. In order to conceive unexpected and lively images, the closed parts of the imagination had to be opened up. Chance, the conscious exploitation of accident, was one of the keys

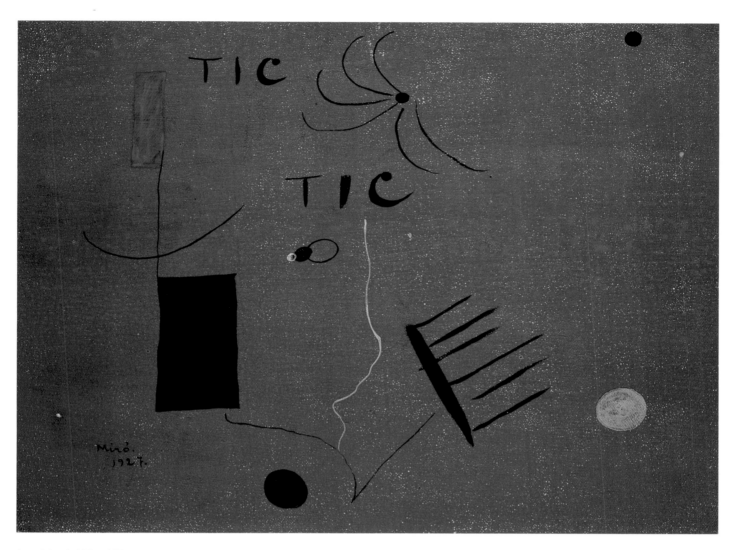

Joan Miró (1893–1983), *Tic Tic*, 1927.

Beetle such as Miró's *Tic Tic* might call to mind.

Miró used. He would scribble or paint as thoughtlessly as possible, staring hard at the chaotic result for some shape or image to appear. Gradually he built up a repertoire of images which in modified form he used repeatedly. That is what Miró did in this painting: he began with the atmospheric blue and then populated it with the creatures of his imagination.

Sometimes, as here, Miró would also add words, not for the sake of the shape of the letters but for their sound and meaning. Here, 'Tic Tic' suggests not so much the sound of a clock but rather the scuttling of beetles and other insects.

Miró would not have been pleased to find himself in this book. As he made clear in an interview of 1936, he was angered by all descriptions of his work as abstract:

> Have you ever heard of greater nonsense than the aims of the Abstractionist group? And they invite me to share their deserted house as if the signs that I transcribe on canvas, at the moment when they correspond to a concrete representation of my mind, were not profoundly real, and did not belong essentially to the world of reality! As a matter of fact, I am attaching more and more importance to the subject matter of my work. To me it seems vital that a rich and robust theme should be present to give the spectator an immediate blow between the eyes before a second thought can interpose. In this way poetry pictorially expressed speaks its own language… For a thousand men of letters, give me one poet.

But that vehement denial reveals a great deal about the several varieties of non-representational art which draw their strength from subtle allusions to reality. Miró's painting is manifestly not as abstract as the Mondrian or the Riley, but its poetry derives from the way in which its forms cannot be read with any clarity. And it should not be forgotten that Mondrian also considered that his art was 'profoundly real'.

Miró's exploitation of chance, the evocative vagueness of his imagery and his belief that the key to all creativity lay in the subconscious are what made him a Surrealist, a member of that group of painters and writers which in Paris during the inter-War years based their art on the theories of Freud.

Miró's small and charming painting is plainly meant to stimulate the imagination and affect the feelings. It is witty enough to make some people laugh. Although it is fascinating simply on the visual level – as an arrangement of shapes, lines and colours – it sets out to do more than delight the eye.

MALEVICH: SUPREMATIST
COMPOSITION: WHITE ON WHITE
All the pictures which have been discussed so far can be divided very

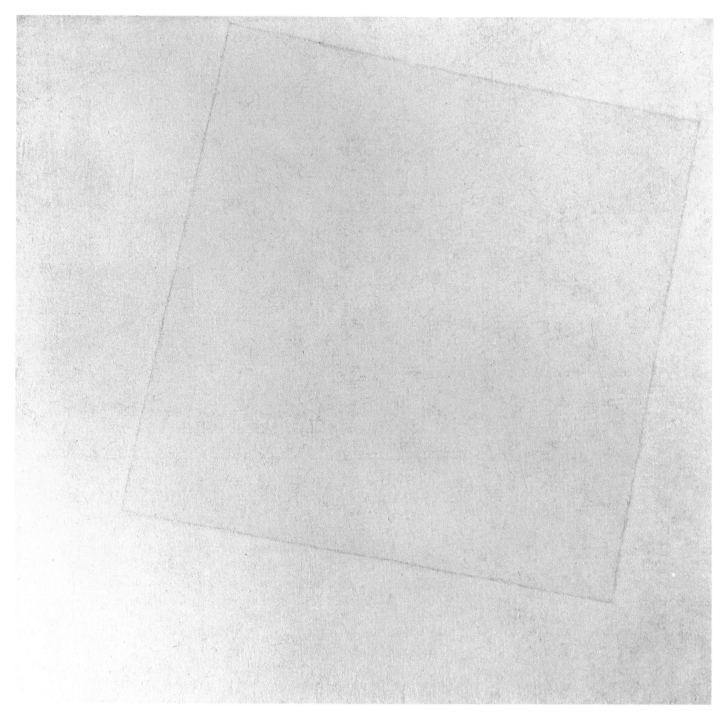

Kasimir Malevich (1878–1935), *Suprematist Composition: White on White*, 1917–18.

loosely into two types. One type employs geometric imagery while the other exploits the potential of less regular forms to allude to nature. Such forms are normally described as 'organic'. In general, the more geometric the imagery, the more disciplined and logical the construction of the picture can be. While the geometric composition can address the intellect more clearly, organic imagery, because of its allusive nature, can speak more directly to the imagination.

The nature of the imagery betrays much about the artist's intentions. External knowledge – of the artist's theories, his personality and creative development – can add considerably to an understanding of those intentions. They are absolutely vital in the case of a work such as *Suprematist Composition: White on White* painted by the Russian Kasimir Malevich as long ago as 1918.

There is an old joke about a painting of a black cat in a coal cellar at

Alphonse Allais (left) *First Communion of Anaemic Young Girls in the Snow*, 1883, and (right) *Apoplectic Cardinals Harvesting Tomatoes on the Shore of the Red Sea*, 1884 (reconstructions).

night. It is not a joke but a fact that in 1883 the French writer Alphonse Allais exhibited a sheet of plain white paper in Paris under the title *First Communion of Anaemic Young Girls in the Snow*. A year later he showed a piece of plain red paper and called it *Apoplectic Cardinals Harvesting Tomatoes on the Shore of the Red Sea*.

The potential for similar works representing other subjects is virtually limitless and the point of all of them would be the humorous relief experienced by the viewer when a title alone transforms something apparently empty into a description; when something worryingly abstract turns out to be reassuringly figurative.

This is not a game that can be played with the Malevich. In spite of the title, there is too much in the composition. The colour and tone of the figure and ground are not quite identical and there is the suggestion of a line around the imperfect square to distinguish the figure from the ground still further.

White on White defeats any attempt to make a joke of the Alphonse Allais variety. Like the Mondrian but unlike the Klee and the Miró, this painting by Malevich sets out to frustrate every desire to 'see something in it'. *White on White* was painted in Russia in 1917–18 and the date is highly significant because it was in October 1917 that the Bolshevik revolution took place. According to the optimistic mood of the moment the old society had been swept away, replaced by something new and potentially perfect.

Malevich fervently supported the revolution and, together with many other artists, believed that the new world now ushered in demanded a new kind of art. For some time Malevich had believed that all traditional and conventional art set an obstacle in the path of living artists and ought to be destroyed – symbolically if not in fact. In 1914 he made a largely abstract composition of paint and collage which includes a small reproduction of Leonardo's *Mona Lisa*, possibly the most celebrated example of a painting universally held to be great, which he ostentatiously crossed out.

A year later Malevich attempted to destroy the art of the past in a less direct way. He exhibited a painting which consisted only of a black square on a square canvas. This was the artistic equivalent of the political revolution which everyone knew was imminent. It was an iconoclastic gesture, a destruction of everything painting was commonly thought to be. It consciously marked the end of an epoch in art history.

Yet the black square was not just a negative gesture. Subversion was only part of its intention. Malevich also wanted it to point towards a new kind of art in which representation was of no importance: it was not a painting of a square, it *was* a painted square which is something quite different.

Knowledge of the black square and of Malevich's intentions adds greatly to an understanding of the white square. It, too, was a dramatic gesture informed by stirring times. It, too, was one of the most radical works of art ever created. Yet it was more.

After symbolically wiping the slate clean with the black square, Malevich quickly made his art more complicated again. Although he restricted himself to geometric forms, he employed a wide variety of rectangles of varying sizes, coloured them in a variety of colours and arranged them at a variety of angles. Colour, angle and arrangement (especially superimposition) combine in such compositions to create the illusion of movement and space.

These paintings are much more complicated than those that followed. Malevich returned to simplicity with white and black paintings which were, however, not quite as absolute as his first black square.

Simply by making the shape in *White on White* irregular and placing it at an angle to the frame, Malevich has introduced a dynamism, a tension between the shape and what encloses it.

Many modern artists, figurative as well as abstract, have felt the need to give a memorable name to their styles. Malevich called what he was doing 'Suprematism' and wrote:

> Under Suprematism I understand the supremacy of pure feeling in creative art.
>
> To the Suprematist the visual phenomena of the objective world are, in themselves, meaningless; the significant thing is feeling, as such, quite apart from the environment in which it is called forth.
>
> The so-called "materialization" of a feeling in the conscious mind really means a materialization of the reflection of that feeling

Malevich, *Black Square*. The painting, intended to mark an absolute break with the art of the past and to announce a new epoch in art history, dates from 1913. It was exhibited in 1915. This illustration is of a later, printed version of the *Black Square* which was published in an anthology of Malevich drawings in 1920.

Malevich in 1900.

through the medium of some realistic conception. Such a realistic conception is without value in Suprematist art...And not only in Suprematist art but in art generally, because the enduring, true value of a work of art (to whatever school it may belong) resides solely in the feeling expressed.

Academic naturalism, the naturalism of the Impressionists, Cézanneism, Cubism, etc. – all these, in a way, are nothing more than dialectic methods which, as such, in no sense determine the true value of an art work.

An objective representation, having objectivity as its aim, is something which, as such, has nothing to do with art, and yet the use of objective forms in an art work does not preclude the possibility of its being of high artistic value.

Hence, to the Suprematist, the appropriate means of representation is always the one which gives fullest possible expression to feeling as such and which ignores the familiar appearance of objects.

Objectivity, in itself, is meaningless to him; the concepts of the conscious mind are worthless.

Feeling is the determining factor...and thus art arrives at non-objective representation – at Suprematism.

It reaches a "desert" in which nothing can be perceived but feeling.

Although Malevich places great emphasis on feeling in this passage (from a book first published in 1927), it is difficult to understand how he thought that his minimal language, the 'desert', was capable of expressing feelings at all. He is hardly more helpful when talking specifically about his *Black Square* painted in 1913 and exhibited in 1915.

When, in the year 1913, in my desperate attempt to free art from the ballast of objectivity, I took refuge in the square form and exhibited a picture which consisted of nothing more than a black square on a white field, the critics and, along with them, the public sighed, "Everything which we loved is lost. We are in a desert...Before us is nothing but a black square on a white background!"

"Withering" words were sought to drive off the symbol of the "desert" so that one might behold on the "dead square" the beloved likeness of "reality" ("true objectivity" and a spiritual feeling).

The square seemed incomprehensible and dangerous to the critics and the public...and this of course, was to be expected.

The ascent to the heights of nonobjective art is arduous and painful...but it is nevertheless rewarding. The familiar recedes ever further and further into the background...The contours of the objective world fade more and more and so it goes, step by step, until finally the world – "everything we loved and by which we have lived" – becomes lost to sight.

No more "likenesses of reality," no idealistic images – nothing but a desert!

But this desert is filled with the spirit of nonobjective sensation which pervades everything.

Even I was gripped by a kind of timidity bordering on fear when it came to leaving "the world of will and idea," in which I had lived and worked and in the reality of which I had believed.

But a blissful sense of liberating nonobjectivity drew me forth into the "desert," where nothing is real except feeling...and so feeling became the substance of my life.

This was no "empty square" which I had exhibited but rather the feeling of nonobjectivity.

I realized that the "thing" and the "concept" were substituted for feeling and understood the falsity of the world of will and idea.

Is a milk bottle, then, the symbol of milk?

Suprematism is the rediscovery of pure art which, in the course of time, had become obscured by the accumulation of "things".

Later still he says:

The black square on the white field was the first form in which non-objective feeling came to be expressed. The square = feeling, the white field = the void beyond this feeling.

Yet the general public saw in the nonobjectivity of the representation the demise of art and failed to grasp the evident fact that feeling had here assumed external form.

It is not surprising that the general public failed to grasp what Malevich intended. A reading of his theories would not make his intentions any less obscure. Nor would he necessarily have failed if his work is appreciated for qualities which he did not intend. *White on White* and works like it might today be thought important largely because they do seem not so much as to proclaim the demise of art as to define its farthest limits.

Many people consider that this painting consists of so little that it cannot be regarded as art at all. Knowledge of the background against which it was made will make them see it in a new light, however. Because of its radical avoidance of everything traditional, it does have an important place in the history of modern art, and that very historical importance alone demands respect.

Knowledge of Malevich's later career will cast further light on *White on White*. The gesture was so radical that it could not be repeatedly made. Unlike Mondrian, who employed a language which, although simple, was capable of almost infinite variation, Malevich found himself seriously limited. To paint even a second *White on White* was in some ways a futile gesture. In the 1920s he abandoned abstraction entirely and took up figurative painting once again. By comparison with his dynamic geometry in which one can sense the excitement generated by both the novelty and the radicalism, Malevich's figurative paintings are dull and clichéd. They might have been painted by anybody at almost any time.

Most artists never return to figuration once they have established an

Barnett Newman (1905–70), *Cathedra*, 1951.

abstract style. Malevich was therefore highly unusual, although the extreme nature of his abstract painting must have left him little choice.

NEWMAN: CATHEDRA

The American Barnett Newman, who established his reputation in the 1950s, developed in the more usual way: he began as a figurative artist and then moved towards abstraction. Together with a number of his contemporaries, among them Jackson Pollock, Newman passed through a Surrealist phase and the automatist technique he employed in creating organic, allusive imagery provided the basis for the abstract style which Newman arrived at in 1946.

Newman's work was always simpler and more controlled than

Pollock's and it quickly became simpler still. This is a good example of the kind of painting Newman continued to produce until the end of his life: a field of a single colour interrupted by one or two vertical lines which run from edge to edge of the canvas.

It might be thought that the simplicity of such a style rivals that of Malevich and that Newman's intentions were therefore similar. This is not so, although Newman did repeatedly speak of the overwhelming importance of feeling in his work. Above all there is a vast difference in scale; and colour plays an infinitely more important role in Newman's work.

No reproduction can ever do justice to a painting by Newman. Most of his works are extraordinarily large, painted with the kind of environment in mind that only a museum can provide. When looking at a

Portrait of Newman

Newman, the viewer should stand close enough to the canvas so that it dominates his field of vision, allowing nothing to intrude even at the periphery. Only then can he fully appreciate the quality of the colour and perceive the subtle variations in the tone and texture across the painting.

The vertical lines assist in this. They mark the progressive stages of looking, setting up relationships between one area of the canvas and another. They also enhance the quality of the dominant colour by means of contrast.

Like most abstract painters, Barnett Newman was a deeply serious man and knowledge of his ideas assists an appreciation of his work. Interested in the art of the Red Indians, for whom abstract shapes and pattern can express religious feelings, Newman felt that all art should be concerned with the deepest, ineffable mysteries of life. Yet how could a painter make such imponderables as death a subject of his work?

Newman believed that none of the existing styles of painting – including all abstract styles – was adequate to the task. In the catalogue introduction to one of his earliest exhibitions in New York he declared that his work was concerned neither with the 'space cutting nor space building' of Cubism nor with 'the pure line, straight and narrow' of Mondrian. Nor was Newman interested in the extreme emotionalism of Expressionism. His work had to be abstract and it had simultaneously to be extremely simple and extremely complex.

It is a difficult paradox, best resolved, perhaps, in terms of figurative art. The more detailed and clear the style in which something is described, the less room is left for the viewer's imagination. The vaguer the imagery, the greater the potential for the viewer's own thoughts and ideas. This is the essential difference between Classical and Romantic art. Jacques-Louis David's *Rape of the Sabines* is bloodless and undramatic. Delacroix's *Death of Sardanapalus* on the other hand is heated and feverish. The difference lies in the nature of the description: Delacroix uses paint suggestively. His edges are purposely vague. As in a horror film, the worst terrors are those provided by the minds of the audience.

Newman wanted his subject-matter to be elemental and primeval, and he believed that the most appropriate language was one in which simplicity and eloquence are combined. Hence the lack of structure and the importance of colour, that element in painting which most directly and powerfully affects the emotions.

Newman's paintings are 'about' colour. The size of the canvas, the edges of the vertical bands, the variations in surface texture are all calculated to enhance the effect of the dominant colour which – if the picture is successful in Newman's terms – will in part determine and in part respond to the viewer's mood.

The viewer's contribution to experiencing the picture is therefore crucial, and to suggest that the effect of this kind of abstract painting depends on what the viewer brings to it is not to minimize the achievement of the painter. If he does too little, the viewer will not be stimulated to look at the picture for long enough to set his imagination

Left: Jacques-Louis David (1748–1825), *Rape of the Sabines*, 1799.

Below: Eugène Delacroix (1798–1863), *Death of Sardanapalus*, 1827.

56　Morris Louis (1912–62), *Third Element*, 1962.

Portrait of Louis.

and senses working; if he does too much, the viewer's freedom to explore himself will be restricted.

LOUIS: THIRD ELEMENT

Matisse's *Snail* is more decorative in intention than the painting by Barnett Newman. It aims to produce pleasant, relaxed feelings in the viewer by means of beautiful colours beautifully related. This is also the intention of *Third Element*. About three quarters of a rectangular canvas is covered with narrow bands of colour, the edges of which occasionally overlap and run into each other. These bands are cut by the left-hand edge but end short of the right side of the canvas in an irregular way. The colours, which range from dark blue to brilliant yellow and red, have not been arbitrarily juxtaposed: they were placed together in an order which makes them seem particularly bright and sonorous.

Morris Louis used such juxtapositions at the top and bottom of his arrangement of bands. The eye is drawn first to one, then to the other, speeding over the bright but less imperious colours in the centre. Since the dark purples and violets at the top seem heavier than the bands at the bottom, there is an imbalance which creates the appearance of movement, of restlessness.

This appearance is enhanced by the way the bands were painted. Streaks rather than strips of pure colour, they rush across the canvas to the right, propelled by some powerful yet unseen source and brought only to a seemingly temporary rest by some invisible force close to the edge of the painting.

Here and in many other works the American painter employed unconventional methods. He did not begin with a sized and primed canvas stretched across a wooden frame to support it. Nor did he use a brush to apply the pigments. He painted on raw cloth, which absorbed the paint as soon as it was applied to it. He poured on the colours one by one and then held up the canvas from what is now the left edge so that the paint ran across it, soaking into the canvas as it went. Although he used quick-drying, plastic paints rather than oils, one area was still wet when the next colour was applied so that the edges of some bands bled into the adjoining areas.

Many of the resulting effects were accidental and, indeed, the method used invited chance to play an important role in the picture's making. This method often produced unsatisfactory results, which were subsequently destroyed. Occasionally, Louis liked what accident had helped him to produce. He would then cut from the canvas the area which made the best picture, stretch and then frame it.

Klee's picture was far less carefully planned than Mondrian's: each mark suggested another as soon as he had made it; he did not set out with a clear image of the painting in his mind; he allowed himself to be surprised. Louis's *Third Element* was planned even less carefully than *Park near L(ucerne)*. When he began he did not even know what the size and format of his picture would be.

Louis felt the need of no metaphysical theory to justify what he was doing. His aim was to provide pleasure to the eye, pleasure that was sufficiently rich and varied to reward repeated examination of the picture. That pleasure derives chiefly from the beauty of the colours and, if the painting can be said to have a subject, it is simply the nature of colour itself. Nothing is permitted to interfere with it.

Louis, *Overlapping*, 1959–60.

<p style="text-align:center">* * * * * *</p>

These eleven pictures are all essentially abstract: they make little or no reference to the outside world, to a world that is familiar from ordinary experience. Yet each picture is different from the next. Each has a different set of aims and each employs a different kind of visual language.

The word 'abstract' applies with equal validity to each of them but, when applied to such different things, it is no more informative than the terms 'figurative' or 'descriptive' would be if used of works by, say, Mantegna, Reynolds or Degas. The differences between them are more important than what they share.

Artists have been making abstract pictures for more than seventy years, and there are almost as many varieties of abstraction as there have

been abstract artists. Some employ geometry exclusively, others natural, 'organic' shapes. Some are interested more in composition than colour. Some use forms which have been derived from nature; others use imaginary elements. Some are frankly decorative, others have more complex and even esoteric aims. Each has to be approached from a different point of view, an attempt made to consider each in its own terms.

In some cases it helps to some extent to know something of the personality, development and intentions of the artist concerned. Such knowledge is helpful but it is rarely essential. Here, however (and by no means only here), greater knowledge contributes to a deeper understanding and therefore to greater pleasure.

Of course, the differences between some of the pictures are greater than those between others. It is clear that the Mondrian and the Riley share not only a limited and regular visual language but are also the result of a disciplined working method. Equally, the Klee, the Kandinsky and the Miró are related in terms of the way in which they allude to natural forms in order to stimulate the imagination. Pure colour celebrated largely for its own sake is what the Matisse and the Louis share.

The eleven pictures were purposely discussed in a non-chronological fashion, as far as possible as independent objects much as they might be encountered on the walls of an imaginary museum. All artists learn from each other, however, and this is as true of figurative as it is of abstract artists. Schwitters was not the first to incorporate pieces of cut and torn paper in his work, nor was he the first to explore ways of making art other than by orthodox methods. He was, however, the first to use the collage medium to produce abstract compositions which share qualities with paintings.

The informal, gestural techniques which Jackson Pollock used yielded highly original results. No-one had made abstract paintings on such a scale before and no-one had produced that kind of imagery. Yet his methods were an extension of those developed by Kandinsky, and used by Miró and others some time before.

A knowledge of art history does contribute to a greater appreciation of all art. To look at a Cézanne landscape knowing something of his debt to the Impressionists is to perceive qualities invisible to someone less well informed. Similarly, Mondrian's relationship to Cubism sheds light on all of his subsequent work.

No artist works in a vacuum. Every work of art he has ever seen exerts, however unconsciously, an influence on what he does. Just as a knowledge of Mondrian's development sheds light on every painting he ever produced, so, too, is his work illuminated by a knowledge of the history of art.

Abstract painting is a relatively recent phenomenon. Why did it appear when it did and why did it appear at all? Why did so many abstract painters devote so much energy to theory, to explaining in words what their intentions were? To answer these questions we must go back to the beginning.

PART TWO

TRACING ABSTRACTION

Cave Painting from Lascaux, *c.* 16000–14000 BC.

ART AND ILLUSION

The earliest paintings known are preserved on the walls of caves in Spain and southern France. Executed no less than 16,000 years ago, they depict animals and men in a way which even now makes them readily recognizable. Indeed, the accuracy with which horses, cattle and men were represented seems to have been vital: by creating faithful images of animals, the artist took possession of them and thus ensured that they would be killed or captured when the hunt began. If the paintings did not succeed in looking like the creatures they represented, their efficacy as magic was impaired.

Ever since prehistoric artists applied colour to the stone walls of caves with such skill, most paintings have been made to represent aspects of reality. In spite of the curious conventions developed by the ancient Egyptians in their depictions of the human figure, the birds and plants which appear in tomb paintings are so accurately depicted that they continue to impress ornithologists and botanists today. And no matter how fantastically transformed or stylized, imagery as different in manner as that created by the ancient Chinese and the Aztecs is fundamentally representational.

Representation was not in itself the principal aim of art such as this; rather it served the aim, which was usually either religious or social, or both. The aim of the early cave paintings was the creation of magic, the acquisition of power over the world by painting pictures of it. The aim of ancient Egyptian painting was religious. The images on the walls of royal tombs exercised, it was believed, a power over the world beyond the grave.

Representation of the real world as the principal aim of art is something peculiarly Western and, what is more, a relatively late development in the history of painting. The idea of making a painting which, when framed and hung on a wall, would create the illusion of a window on to the world outside first entered European art in the fifteenth century and came to dominate it only about a hundred years later. It remained important for some three centuries, however, and the

development of painting during that period can best be understood in terms of a search for pictorial conventions that would create an ever more convincing illusion of what the eye sees.

SEEING AND KNOWING

It is worth repeating that painting which aimed *principally* at representation appeared relatively late in the history of art and then only in a relatively small part of the world. What is more, the reality which such painting seeks to represent is very limited.

When Cézanne described Monet as 'only an eye', he isolated the strengths and weaknesses of French Impressionism. Monet and his friends sought to create a convincing illusion of only a relatively narrow aspect of reality. In their landscapes they sought to depict nature in terms of a tiny part of it, perceived at one particular, fleeting, unique and unrepeatable moment. They succeeded so brilliantly that for most people today the idea of reality in art is an Impressionist landscape. But Cézanne – who added to his criticism of Monet the words of admiration 'but, my God, what an eye!' – knew that reality was more complex than an Impressionist painting suggested. He knew that there was more to the perception of reality than the eye. It took a mind as well.

What the mind knows rather than what the eye sees determined the ancient Egyptian way of painting the human figure which looks so strange – head and legs in profile, torso to the front and two left feet. What looks strange is perfectly logical. Each part of the body is shown from what was deemed to be the most informative angle. Legs seen directly from the front are not as 'leg-like' as legs seen from the side.

The misleading result of depicting something from an unfamiliar angle, of showing it perceptually rather than conceptually, is the point of

Claude Monet (1840–1926), *Route à Louveciennes, neige fondant, soleil couchant*, 1870.

the guessing game that was popular some years ago. What is the subject of the two drawings shown here? The Mexican on a bicycle and the giraffe observed through a keyhole are two examples of what happens when our expectations of appearances are frustrated by the surprising effects of looking at things from unusual angles or positions.

What crucially determines the way reality is represented in a painting or drawing is the kind of information the artist wishes to convey. A painting of a kestrel intended as an illustration in a bird-watcher's manual will be inadequate unless it shows all the bird's peculiar characteristics. In medical textbooks paintings executed by specially trained artists are preferred to photographs because they convey more essential information than a camera ever could. In both cases distortions may be necessary to make a point. Exaggeration enhances the truth.

SYMBOL AND ALLEGORY

Not only has the nature of reality been construed differently by various artists at various times but the purpose of depicting it has frequently changed as well.

Jan Van Eyck's *Betrothal of the Arnolfini* might seem a remarkably successful portrait, a convincing record of the appearance of two people at an important moment in their lives. The apparently faithful way in which the artist has created the illusion of the interior might be thought especially impressive. This, surely, is precisely the way the room must have looked at the time.

Yet most of the details in the painting are present for a reason other than that they were there when the artist painted his picture. They have a specific symbolic function: they allude to the presence of the Holy Spirit (the single candle in the chandelier), the sanctity of the moment (the shoes on the floor and the brush in the background, both indicative of holy, purified ground), the virtues of a good marriage (loyalty symbolized by the dog), the relationship between sexuality and the Fall of Man (the apples on the window sill) and the consummation of the marriage vows (the bed).

Jan Van Eyck (*c.* 1390–1441), *Betrothal of the Arnolfini*, 1434.

Jan Vermeer (1632–75), *The Art of Painting*, *c.* 1666.

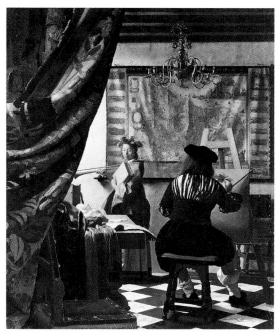

What at first sight appears to be a faithful, breathtakingly realistic representation of what the artist actually saw turns out to be fictitious, an illusion of reality serving complex ends. Something similar is true of Jan Vermeer's *The Art of Painting* which also provides a striking illusion of reality.

Vermeer's picture used to be called *The Artist in his Studio*, a perfectly adequate and descriptive title until it was realized that most of Vermeer's paintings have, for all their realism, a deeper, allegorical purpose. The map of the Netherlands in the background, the dress of the model together with the trumpet she holds, contribute to a meaning which, although unclear, seems to be about the state and reputation of Dutch painting at the time.

Edward Collier (1663–1706), *Trompe l'œil painting, c.*
1695–1700.

William Hogarth (1697–1764), *Moses Brought before*
Pharaoh's Daughter, c. 1764.

ART AND THE ACADEMY

Only rarely in the history of art has the aim of creating a convincing illusion of reality been pursued for its own sake. Indeed, an artist satisfied with mere illusionism traditionally has not been highly regarded. '*Trompe l'œil*', the name given to painting which actually tricks the eye into believing it is looking at real objects rather than painted representations, provides intense but brief fascination. Art, it is instinctively felt, ought to be more than a kind of deception; otherwise an artist who specialized in *trompe l'œil* compositions of letters and other pieces of paper stuck into racks would be more highly regarded than Leonardo.

What art should be about and how it should affect its public were the concerns of the art academies which were founded throughout Europe in the seventeenth and eighteenth centuries to enhance and defend the status of the artist, and to set and preserve standards in architecture, painting and sculpture. According to academic doctrine, the more a painting was instructive and morally uplifting, the more worthy of attention it was.

The best paintings told educational and elevating stories. It was not that painters should not concern themselves with other types of subject – with the landscape, for example, or the still life – just that these subjects were inferior to narrative themes because they offered little more to the spectator than what he could see for himself.

Academic doctrine therefore resulted in a hierarchy of subject-matter, at the summit of which were themes derived from the Bible, Classical mythology and history. Such art was known as 'history painting', and it was in the handling of such subjects that an artist showed his greatness. He might be a talented landscapist, his still lifes might be much admired, but he could not be a truly great painter.

The widespread acceptance of the academic hierarchy explains why the English painter William Hogarth wasted so much time trying to produce pictures of Biblical and mythological subjects rather than concentrating on satire, the area in which his gifts manifestly lay. Satire was not highly regarded by the academic mind. The tyranny of the hierarchy of subject-matter also explains why John Constable was an old man before the Royal Academy in London elected him as a member and why he was always anxious to argue that there was a moral dimension to landscape painting. Constable was determined to demonstrate that landscape was the equal of history painting. His contemporary, Turner, would compromise, make a gesture towards conforming, by giving his landscapes titles that were more appropriate to history pictures. In *Hannibal and his Army Crossing the Alps*, for example, almost nothing can be seen of the army with its elephants. It is a dramatic painting of a storm masquerading as a history picture.

John Constable (1776–1837), *The Glebe Farm*, c. 1830.

Joseph William Mallord Turner (1775–1851), *Snow Storm; Hannibal and his Army Crossing the Alps*, 1812.

Narrative remained important in European painting until the second half of the nineteenth century. By then it had come increasingly under attack by artists who believed that art should concern itself with the real world, with common experience, with the ordinary and mundane. The public continued to have its difficulties, however, and even a century later there are many people who think that every painting should tell a story, who look for topics everywhere and even find them where none was intended.

The change in attitude to subject-matter in painting which occurred in the nineteenth century in France is dramatically illustrated by the work of Edouard Manet. Manet admired the Old Masters, respected tradition and yearned for official academic recognition, yet he was too honest to be content with the thoughtless repetition of old and outdated pictorial conventions. So he brought them up to date, seeking simultaneously to conserve what was still vital and replace the moribund with the contemporary and real.

Edouard Manet (1823–83), *Déjeuner sur l'herbe*, 1863.

Déjeuner sur l'herbe draws heavily on tradition. There are several precedents in Renaissance painting for the group of clothed males and naked female sitting in the open air, and the arrangement of the figures is derived from a Raphael. Yet Manet dresses the men in contemporary clothes and the faces are obviously those of individuals then living. The public which first saw Manet's picture chose to ignore the borrowing and, expecting a story, found one of a salacious kind that was not intended.

The public's reaction to Manet's *Olympia*, which was an attempt similarly to breathe new life into a tired tradition, was even stronger. The nude woman, who would have inspired little comment had she been a Venus or some other classical divinity, looked to the public like a contemporary. Her body had scarcely ideal proportions and her face seemed very modern. Once again a story was looked for and found. The woman was a courtesan receiving a lover. *Olympia* was pornography.

The attack on Manet's subject-matter was made with ammunition supplied by academic doctrine. But the attack was not on subject-matter alone. Some critics also found fault with the artist's style. They considered it vulgar in its exaggerated tonal contrasts, crude in its use of bright local colour and inept in its lack of modelling. One of them compared the appearance of one of Manet's paintings to that of a playing-card.

There is indeed a lack of modelling in the *Olympia*, and it is accompanied by a general flatness in every part of the picture. The black maid is virtually the same tone as the cat on the bed and both are almost as dark as the background. The triangle of the bed revealed by the sheet at the bottom left is the same colour and tone as the wall behind the woman. Her body is tipped slightly towards the viewer. All these devices result in a flat arrangement of shapes which Manet clearly intended the viewer to notice and to enjoy. Obviously many painters before Manet intended their handling of paint, their colour and compositional skills to

be enjoyed, but there is something new about the extent to which Manet exploits decorative qualities – makes patterns – while dealing with his subject in other unconventional ways.

PAINTED MUSIC

A changed attitude to subject-matter and an interest in decorative pictorial qualities took a different form in the work of a painter who knew Manet well.

James McNeill Whistler, an American who divided his time between Paris and London, gave to paintings the titles *Nocturne, Arrangement, Harmony* before adding, almost as an afterthought, what was represented. Thus *Nocturne in Blue and Gold* has the subtitle *Old Battersea Bridge*, while the *Arrangement in Grey and Black No. 1* turns out to be the celebrated portrait of Whistler's mother.

The title implies that this is not a portrait in any conventional sense. The precise composition, the careful inter-relation of rectangles against which the figure appears in profile, are at least as important as the likeness of the woman and far more so than what is revealed of her personality or mood. Also more important is the subtle arrangement of tones which creates gentle contrasts and the often minimal differences in tone between one area and another.

The title of this picture – *Arrangement* – and others of the same period such as *Nocturne, Harmony, Variation, Symphony* – are borrowed from music and suggest that Whistler intended his audience to look for parallels between his painting and musical composition. He certainly wanted them to look for purely visual qualities first, before judging his pictures as representations of reality. This is part of his definition of a *Nocturne*: 'I have perhaps meant rather to indicate an artistic interest alone in the work, divesting the picture from any outside sort of interest which might have been otherwise attached to it. It is an arrangement of line, form and colour first, and I make use of any incident of it, which shall bring about a symmetrical result.' Whistler draws attention to the way in which he exploits particular qualities – colours, tones, forms and lines – and, by giving the musical title precedence over the descriptive title, announces that such qualities are more important than the ostensible subject. Whatever is represented – an old lady, a beautiful girl in a white dress, a bridge over the Thames – is less important than the interplay of shapes and tones to which they give rise.

To avoid exaggeration, it should be said that the representational subject continued to be vitally important to Whistler. But by suggesting, however tentatively, that painting is pre-eminently an arrangement of abstract qualities and only after that a description of some aspect of reality, Whistler was turning his back on tradition, looking forward to a kind of art that lay in the future and preparing the way for it.

Whistler was not alone in using musical terminology to describe the pure qualities of painting and thus in suggesting that there are deep affinities between music and the visual arts. He was not alone, but he was

James Abbott McNeill Whistler (1834–1903), *Arrangement in Grey and Black No. 1 (The Artist's Mother)*, 1867–72.

Whistler, *Nocturne in Blue and Gold: Old Battersea Bridge*, 1872–75.

71

Edvard Munch (1863–1944), *The Scream*, 1893.

Paul Sérusier (1864–1927), *Landscape of the Bois d'Amour at Pont-Aven: the Talisman*, 1888. This small painting was executed on the lid of a cigar box. When Gauguin finally agreed to give Sérusier the painting lesson which he had repeatedly requested, there was nothing more suitable to hand. Since the wood was neither sized nor primed, it absorbed a great deal of paint and the colours have become dimmed over the years.

far outnumbered by those who believed that painting shares most with literature, that poetry not music is the sister art of painting.

To anyone convinced that the main purpose of painting was to tell stories, the idea that painting might have anything in common with music was too ridiculous to contemplate. Yet it was an idea which gained a foothold during the nineteenth century and which eventually produced the even more radical notion that music is the highest form of art, to which all others ought to aspire.

After Whistler, numerous artists employed musical terms in their titles or alluded to music in other ways. The French Symbolist Odilon Redon proudly called himself a 'symphonic painter', and Art Nouveau artists frequently had recourse to such titles as *Sun Sonata*, *Andante* and *Scherzo*. A result of the same conviction that the ear and the eye are intimately related is Edvard Munch's *The Scream*. Swirling bands of red and yellow not only suggest the reverberations of the sound in the air but actually evoke a high-pitched, pulsating scream. Paul Gauguin, too, made a reference to music when attempting to describe what he was doing in one of his paintings.

Like Cézanne, Gauguin had worked for a time in an Impressionist manner but had also come to the conclusion that there was more to painting than the representation of limited, transient aspects of reality. In a way quite different to that developed earlier by Whistler, Gauguin began to emphasize qualities inherent in painting. He made his colours brighter, his lines stronger and, so as to create bold patterns, his compositions flatter.

Gauguin stressed the decorative aspects of his paintings and taught others to do the same. When the young Paul Sérusier travelled to Brittany and pestered Gauguin for a lesson, Gauguin took him to a nearby wood and told him to exaggerate and simplify everything he saw. 'How do you see this tree? Is it really green? Use green then, the most beautiful green on your palette. And that shadow, rather blue? Don't be afraid to paint it as blue as possible.'

On another occasion Gauguin advised a friend, an amateur painter, not to paint too much after nature: 'Art is an abstraction; derive this abstraction from nature while dreaming before it, and think more of the creation which will result than of nature'. This extraordinary statement insists absolutely on the autonomy of painting. A painting is not an illusion of something in nature. Nature is of use only insofar as it provides an artist with the material from which he can derive what he needs.

The decorative, pattern-making aspect of painting was crucially important to Gauguin, but it was not his prime interest. He believed that a painting ought to be about more than pleasant arrangements of colours. Although an opponent of everything academic, Gauguin believed that a painting should tell a story, and he believed that painting could be used for previously unimagined methods of narrative.

The subject of *Vision after the Sermon: Jacob Wrestling with the Angel* is not quite what it might at first sight appear to be. Far from

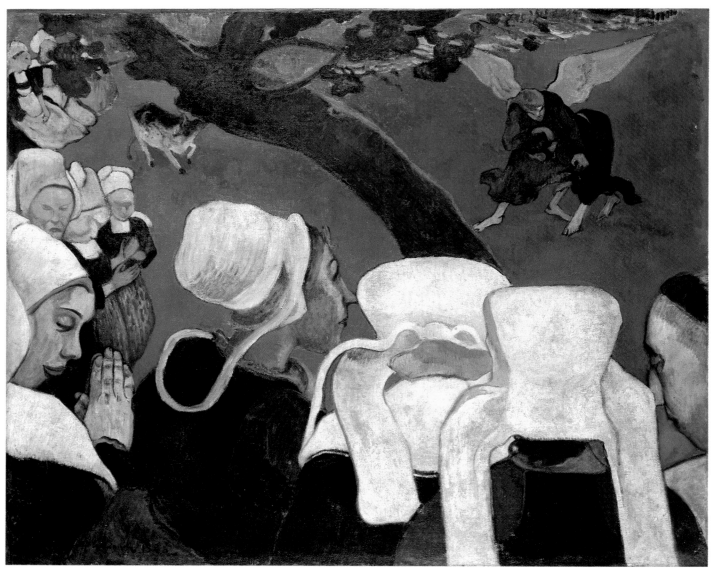

Paul Gauguin (1848–1903), *Vision After the Sermon: Jacob Wrestling with the Angel*, 1888.

describing something real, it presents an event seen only in the imagination of a group of devout, unsophisticated Breton women. Conjured up by a sermon in church, the vision appears against a vivid scarlet background, an unnatural colour chosen to signal the unreality of the scene.

Colour is therefore used not naturalistically but symbolically here. It plays an important part in the decorative ensemble of clear areas of bright colour and heavy, curving outlines in which no attempt has been made to depict space and volume. Gauguin was so concerned with these two elements that they almost take on a life of their own. The contours of some of the bonnets exist not so much as descriptive outlines but as effects in their own right with special characteristics such as rhythm.

The kind of narrative which Gauguin introduced into his work became more ambitious later, when he was living and working in the South Seas. There he attempted to use colour and line not only to tell stories but to express feelings and ideas.

Gauguin himself described the ostensible subject of his painting *Manao Tupapau (Spirit of the Dead Watching)* as 'A young Tahitian girl...lying on her stomach, showing part of her frightened face'. But he quickly makes it clear the true subject is the *tupapau*, the spirit of the dead, and the fear it inspires. In his description of his painting Gauguin divides the work into two parts. There is 'The literary part: the spirit of a living person linked to the spirit of the dead. Night and Day'. But there is also – significantly – 'The musical part: undulating horizontal lines; harmonies of orange and blue, united by the yellows and purples (their derivatives) lit by greenish sparks'.

The musical part is the non-representational part of the picture, that part which is most directly intended to communicate the feeling of fear which is Gauguin's true subject.

It was not only in his description of this painting that Gauguin used musical terminology. He repeatedly referred to the 'colour orchestration' of his pictures and to the effect of painting which 'like music affects the soul indirectly via the senses'.

Gauguin, *Manao Tupapau (Spirit of the Dead Watching)*, 1892.

NIGHT CAFÉ

Vincent Van Gogh, Gauguin's contemporary and, for a time, his friend, also attempted to make painting express emotions and ideas in a new way. Van Gogh's work is chiefly about his feelings, about the moods inspired in him by his experience of nature and people, and these feelings are expressed by means of heightened colours, exaggerated marks of the brush and other, chiefly compositional, means. The *Night Café* is not just a description of a place which Van Gogh knew almost as well as his own bedroom, it is also, in the artist's own words, an expression of 'the idea that the café is a place where one can ruin oneself, go mad or commit a crime'.

Something of the atmosphere of mental imbalance is established by the composition and especially by the high, unnatural viewpoint which induces a feeling of giddiness by making the floor seem to rush sickeningly away beneath the spectator's feet. But in a letter to his brother Theo, Van Gogh made it clear that his chief means of expression was colour:

> *I have tried to express the terrible passions of humanity by means of red and green.*
> *The room is blood red and dark yellow with a green billiard table in the middle; there are four citron-yellow lamps with a glow of orange and green. Everywhere there is a clash and contrast of the most disparate reds and greens in the figures of the little sleeping hooligans, in the empty, dreary room, in violet and blue.*

Vincent Van Gogh (1853–90), *Night Café*, 1888. This the interior of the café in Arles where the artist spent much of his time when he was not working. The place held a special significance for him, not least because there was a brothel upstairs, reached through the door at the rear.

76

The blood-red and the yellow-green of the billiard table, for instance, contrast with the soft tender Louis XV green of the counter, on which there is a pink nosegay. The white coat of the landlord, awake in a corner of that furnace, turns citron-yellow, or a pale luminous green.

This wonderfully evocative passage testifies not only to Van Gogh's remarkable sensitivity to colours and the often subtle differences between them, but also, and more importantly, to the effect which certain juxtapositions of colour had on his emotions.

It is one thing for Van Gogh to be affected in a particular way by specific combinations of colours; it is another for other people to be affected by them in the same way, whether they appear in his painting or somewhere else.

Gauguin was certainly aware of the probability that the 'musical part' of *Spirit of the Dead Watching* would not strike the spectator in the way he intended. The final two sentences of his description of the painting quoted above imply that the only audience he was truly interested in reaching consisted of those who were naturally sensitive to colours and lines in the way he himself was: 'This genesis is written for those who must always know the *why* and the *wherefore*.

Otherwise it is simply a study of an Oceanic nude.'

The question remains: were Van Gogh and Gauguin deluding themselves about the expressive potential of lines and colours? Do we need Gauguin's explanation to grasp that *Spirit of the Dead Watching* is more than 'simply a study of an Oceanic nude'?

ART AND PSYCHOLOGY

During the second half of the nineteenth century there was an explosion of scientific activity. Discoveries were made in chemistry, physics and all branches of technology so major that they transformed every common view of the world. There were also developments in psychology, in the way we understand ourselves and the relationship between the five senses and our brain.

While Van Gogh and Gauguin were formulating their subjective theories, scientists (especially in Germany and the United States) were conducting experiments to determine precisely how the eye sees and, of special interest here, whether visual phenomena can affect the emotions.

The fact that certain colours have been used in a symbolic way since time immemorial – in most cultures red signals alarm and white signals purity, for example – suggests that there is at least a link of some kind between what we see and what we feel. That link has been demonstrated in industry where one workshop with walls painted in a bright colour had better production figures than another decorated in 'more restful' shades.

Van Gogh and Gauguin were unaware of the experiments being conducted at the time. Two of their contemporaries were well aware of

them, however, and based some of their pictorial methods on the conclusions. These painters were Georges Seurat and Paul Signac.

Initially, Seurat was much more interested in the precise way the eye sees colour than in its potential for expression, and his system of painting with dots of pure colour, known as 'Pointillism', or 'Divisionism', was in part based on the findings of such scientists as Helmholtz and Rood. But then, at least according to one of his friends, Seurat asked himself: 'If, with the experience of art, I have been able to find scientifically the law of pictorial colour, can I not discover an equally logical, scientific, and pictorial system to compose harmoniously the lines of a picture just as I can compose its colours?'

Seurat was considerably helped in his search by a young scientist whose interests embraced physics, optics and the arts. It was in 1884 that Charles Henry began to investigate the emotional properties of lines. He restricted himself initially to such vague questions as what was 'agreeable' and what was 'disagreeable'.

Significantly, Henry was also interested in music, and in the affinities between music and painting. Even before he came across Henry, Seurat was similarly interested, perceiving connections, for example, between the seven hues of the spectrum and the seven notes in the octave (one, of course, is repeated). Here, too, the search for the emotional properties of colours and lines was intimately bound up with a fascination for music.

Signac, Seurat's friend and disciple, was interested in music, too. He numbered his works as though they were musical compositions and called some of his seascapes *Scherzo* or *Adagio*. Signac actually worked with Henry on several projects, including some in 1888, the year in which Van Gogh painted the *Night Café*. One of these projects was a book with the explanatory title *Aesthetic Table with a Notice on its Application to Industrial Art, to the History of Art, to the Interpretation of the Graphic Method and in General to the Study and Aesthetic Rectification of all Forms*.

The relationships between emotions, lines and forms which Henry isolated were relatively simple. Anything which suggests or follows a direction from left to right or moves in an upward direction is associated with pleasure, while opposite directions provoke an opposite response. Henry also postulated connections between colours and emotions where, roughly, warm colours (for example red and orange) are agreeable while cold colours (above all blue) are disagreeable.

In spite of the rudimentary nature of such findings, Seurat believed that he could base a pictorial and compositional method on them. This method is the cause of the strange stylization in pictures such as *La Parade* and *Circus*. In *Circus* the combinations of bright, hot colours and the emphasis on erect, upward-curving forms – as seen in the clown's wig and in every part of the bare-back rider, from the crisp lift of her skirt to the attitude of her arms – are intended to express a mood of excitement, gaiety and vitality.

Maximilien Luce (1858–1941). *Portrait of Signac.*

The extent to which Seurat had formulated a coherent theory by this time is made clear by a letter he wrote in 1890.

> *Aesthetic Art is Harmony. Harmony is the analogy of contrary and of similar elements of tone, of colour and of line, considered according to their dominants and under the influence of light in gay, calm, or sad combinations.*
>
> *The contraries are:*
>
> *For tone, a more* { *luminous* / *lighter* } *shade against a darker*
>
> *For colour, the complementaries, i.e., a certain red opposed to its complementary, etc. (red-green; orange-blue; yellow-violet).*
> *For line, those forming a right-angle.*
> *Gaiety of tone is given by the luminous dominant; of colour by the warm dominant; of line by lines above the horizontal.*
> *Calm of tone is given by an equivalence of light and dark; of colour, by an equivalence of warm and cold; and of line, by downward directions.*

The scientific ring of this passage is striking. Seurat was searching for the certainty of science in developing his method of painting.

By stressing the decorative qualities of painting – colour, form and line for their own sake – Gauguin also drew attention to the fact that a painting, even if it creates the illusion of being a landscape, a portrait or something else, is also an object in its own right. Before it is anything else, a painting is a flat surface with pigment on it.

Georges Seurat (1859–91), *Invitation to the Sideshow (La Parade)*.

Seurat, *Circus*, 1890–91.

THE REAL AND THE ILLUSORY

While Gauguin, Van Gogh and Seurat were exploring new methods of expression, Paul Cézanne was attempting to resolve the paradox implicit in any attempt to create an illusion of a three-dimensional reality in two dimensions, in other words on a flat surface. His solution was to create an illusion while at the same time stressing the flatness of the surface on which the illusion appears. This accounts for the odd distortions in scale and shape, and for the brushwork which always draws the viewer's attention to the surface of the picture and the quality of the paint.

The very idea of abstraction would have seemed lunatic to Cézanne even had it occurred to him. But his recognition that a painting is an object in its own right, itself part of reality, was an important step in the direction of abstraction.

Cézanne's art also reflects contemporary philosophical questions about the nature of reality prompted by advances in science and the

Photograph by the nineteenth-century French photographer Edouard Baldus of the Pont du Gard, Nîmes, c. 1860. From the middle of the nineteenth century painting had to compete with the phenomenal success of photography.

confusion about the purpose of painting caused by the invention and phenomenal success of photography. If the camera could produce illusions of reality more convincing and objectively more true than any artist, what was the artist to do? One answer was to paint what was beyond the range of the lens. Another was to think about the differences between the lens and the human eye. Cézanne realized that sight is not something passive. It is the result of knowledge, expectation, thought and memory.

Impressionism emerged at the moment when photography was enjoying its first triumphs. It is surely not a coincidence that it also marked the moment at which most artists ceased to regard the primary purpose of painting as the creation of convincing illusions of visible reality.

ACHIEVING ABSTRACTION

In 1890 Maurice Denis, one of the painters profoundly influenced by Gauguin, published his celebrated statement about painting: 'It must be remembered that any painting – before being a war horse, a nude woman, or some anecdote – is essentially a flat surface covered with colours arranged in a certain order'. Whistler and Seurat, as well as Gauguin, would have understood this comment, but none of the three artists took the logical step of abandoning the use of subject-matter altogether. In the case of Seurat, any experiments leading in this direction would have been cut short by his tragically early death at the age of thirty-two.

It is significant that one of the first to banish illusionism, which had dominated European image-making for so long, was a Slav from Russia, a country where European traditions in painting had been adopted only comparatively recently. In short, representation was foreign to the Russian artist's notion of what art should be.

It was not only Kandinsky's 'Russianness', his closeness to the traditions of icon painting, that equipped him to think of image-making in a new way. He was very gifted intellectually and had read widely in a variety of fields by the time he decided to become an artist, at the advanced age of thirty.

He had also been born with an unusual gift, the results of which are known to psychologists as 'synaesthesia': when one sense is stimulated, another reacts. In Kandinsky's case the eye and the ear were linked especially closely, to the extent that when he saw a colour he would hear not merely a generalized sound but a specific note played on a specific instrument. The reverse was also the case: a particular sound would evoke not a vague but a quite specific colour, such as a chrome yellow or alazarin crimson.

For Kandinsky, then, the parallels between music and painting were not a matter for speculation or assertion, they were a fact. Kandinsky also knew that the connections between auditory and visual experiences and the feelings were a fact. Sounds and the colours related to them always evoked the same mood in him.

Paul Cézanne (1839–1906), *Still life with Plaster Cupid*, c. 1895. This is one of the most puzzling of the compositions in which Cézanne achieved a precarious balance between the demands of representation and the need to make a tight, coherent composition. Is the still life standing on a low table or directly on the floor? Is the round object in front of the painting at the rear an apple or something much larger than any fruit? Where does the 'real' piece of blue material beneath the still life end and the representation of the blue material in the painted still life propped up against the wall on the left begin? Such questions can never be satisfactorily answered, but to ask them is to be reminded that this is not simply a representation of reality but a painting with a life of its own.

84 Caspar David Friedrich (1774–1840), *Traveller Looking over the Sea of Fog*, c. 1818.

If Whistler and Gauguin perceived certain parallels between painting and music, Kandinsky saw truly deep affinities, and he was determined to make painting as much like music as possible. For him, as for many artists and theorists of an earlier generation, music was the purest art form, which all others should to seek emulate.

Whistler was by no means the earliest artist to suggest that parallels existed between music and painting. It was the Romantics, above all the German Romantics, who first perceived deep and obscure connections between the heard and the seen. Painters such as C.D. Friedrich and P.W. Runge repeatedly compared paintings and music in their writing, as did contemporary philosophers – such as Tieck – and poets such as Novalis.

These theories were half forgotten – as were the German Romantics themselves – but they re-emerged at precisely the moment when Kandinsky was considering the possibilities of abstraction.

Kandinsky was not alone among his contemporaries in his belief that the affinities between music and painting provided an obvious line of approach to abstract art. Nor was it only painters who were interested in exploring these alleged affinities. Some composers suggested colour equivalents for notes. Schönberg spoke of 'colour chords', but he did not go as far as the Russian Scriabin, who in his symphony *Prometheus* included a line for a 'colour organ' which, with a conventional keyboard, projected combinations of colours on to a screen while the orchestra played. Kandinsky knew Scriabin and *Prometheus* well.

If a poet wishes to convey his deepest feelings, he is obliged to do so in words which have a universally agreed meaning. If a painter wants to express a mood, he has to do so within the constraints of recognizable subject-matter. So reasoned Kandinsky. Only the composer of music has at his command a language which, independent of the outside world and self sufficient, can directly communicate emotion. It is for this reason, Kandinsky thought, that music has the power to move more people more deeply than any other means of expression.

With his sharp analytical mind, and greatly assisted by his knowledge of perceptual psychology, Kandinsky began to search for the fundamentals of the language of painting much as a linguist searches for the fundamentals of a hitherto unrecorded dialect in order to codify its grammar. For Kandinsky each colour has a meaning, is capable of affecting the feelings in a quite specific way. That meaning is modified when the first colour is affected by a second, and so on.

What is true of colour is also true of form and of line. A line langorously slipping downwards (the words in this description inevitably have emotional connotations) obviously suggests a mood quite different from a straight mark which thrusts its way diagonally across the page. Even the simplest contrast of lines imaginable, the vertical and the horizontal, establishes contrasting moods: the one active and alert, the other passive and at rest.

Diagrammatic representation of three faces expressing three quite distinct moods.

Kandinsky knew that his theory of a basic visual language represented merely the start of an investigation, and that it provided him with knowledge sufficient only to stammer the most elementary things in the language. The work of later generations would expand and refine that knowledge. He was painting the visual equivalent of medieval plainsong; symphonies in paint would have to wait for a future composer.

Kandinsky was thinking about abstract painting and the possibility, necessity even, of banning all 'realistic' motifs from his work as early as 1908, perhaps even earlier. Certainly he had had several earlier experiences which proved crucial in forming his ideas.

One of the earliest and most influential occurred while he was still living in Moscow. Visiting the Tretyakov Gallery one day, a collection he knew very well, he was surprised by the sight, some distance away, of a ravishingly beautiful painting which he did not remember having seen before. To him, most extraordinary of all was the realization that the painting had no realistic subject: it consisted entirely of colours and tones which created an illusion of light.

Only when Kandinsky moved closer did he recognize the painting. He had seen it before and it had a subject. It was one of Monet's paintings of haystacks. 'And unconsciously the object was discredited as an indispensable element of a painting.'

Such early experiences (including the sight of one of his own canvases upside down on the easel) formed his determination to eliminate the subject from his painting and to establish the new art on firm foundations.

He realized that nature and art are two entirely different things and, as he put it in his autobiography, this realization:

> freed me and opened new worlds to me. Everything "dead" trembled. Not only the oft-sung stars, moon, woods, flowers, but also a cigarette butt lying in the ash tray, a patient white trouser button peeking up out of a puddle in the street, a docile bit of bark being pulled through the high grass in the strong jaws of an ant to uncertain and important purposes, a calendar page after it is torn from the warm society of its fellows on the block by the outstretched, conscious hand – everything showed me its face, its innermost being, its secret soul that more often keeps silence than speaks. Thus every resting point and every moving point (= line) became just as alive and revealed to me its soul. That was enough for me, enough to understand with my whole being, with my total senses, the possibility and the existence [being] of art, which today in contrast to "objective" is called "abstract".

For several years Kandinsky worked on his first important theoretical statement *Concerning the Spiritual in Art*, which was eventually published in 1912. Even then, however, he had not quite arrived at abstraction, or what he preferred to call 'non-objectivity', in his own

painting. Indeed, the route he chose to follow in practice was rather different from the one suggested by the theory.

Something of the flavour of Kandinsky's theories can be sensed in the following extracts from *Concerning the Spiritual in Art*, much of which is about colour:

> *If you let your eye stray over a palette of colors, you experience two things. In the first place you receive a purely physical effect, namely the eye itself is enchanted by the beauty and other qualities of color. You experience satisfaction and delight, like a gourmet savoring a delicacy. Or the eye is stimulated as the tongue is titillated*

Monet, *Haystack at Sunset*, 1891. This is not the painting which Kandinsky saw in the Tretyakov Gallery in Moscow but it belongs to the same series in which Monet pushed his representation of light and atmosphere so far that the objects depicted seem to dissolve. It is not difficult to see how such a painting might persuade Kandinsky that abstraction could be achieved.

87

by a spicy dish. But then it grows calm and cool, like a finger after touching ice. These are physical sensations, limited in duration. They are superficial, too, and leave no lasting impression behind if the soul remains closed. Just as we feel at the touch of ice a sensation of cold, forgotten as soon as the finger becomes warm again, so the physical action of color is forgotten as soon as the eye turns away. On the other hand, as the physical coldness of ice, upon penetrating more deeply, arouses more complex feelings, and indeed a whole chain of psychological experiences, so may also the superficial impression of color develop into an experience.

More important than any superficial impression, however, is the psychological effect of colours:

> *They produce a correspondent spiritual vibration, and it is only as a step towards this spiritual vibration that the physical impression is of importance.*
>
> *Whether the psychological effect of color is direct, as these last few lines imply, or whether it is the outcome of association, is open to question. The soul being one with the body, it may well be possible that a psychological tremor generates a corresponding one through association. For example, red may cause a sensation analogous to that caused by flame, because red is the color of flame. A warm red will prove exciting, another shade of red will cause pain or disgust through association with running blood. In these cases color awakens a corresponding physical sensation, which undoubtedly works poignantly upon the soul.*
>
> *If this were always the case, it would be easy to define by association the physical effects of color, not only upon the eye but the other senses. One might say that bright yellow looks sour, because it recalls the taste of a lemon.*
>
> *But such definitions are not universal. There are several correlations between taste and color which refuse to be classified. A Dresden doctor reported that one of his patients, whom he designated as an "exceptionally sensitive person", could not eat a certain sauce without tasting "blue," i.e., without "seeing blue". It would be possible to suggest, by the way of explanation, that in highly sensitive people the approach to the soul is so direct, the soul itself so impressionable, that any impression of taste communicates itself immediately to the soul, and thence to the other organs of sense (in this case, the eyes). This would imply an echo or reverberation, such as occurs sometimes in musical instruments which, without being touched, sound in harmony with an instrument that is being played. Men of sensitivity are like good, much-played violins which vibrate at each touch of the bow.*
>
> *But sight has been known to harmonize not only with the sense of taste but with the other senses. Many colors have been*

described as rough or prickly, others as smooth and velvety, so that one feels inclined to stroke them (e.g., dark ultramarine, chrome-oxide green, and madder-lake). Even the distinction between warm and cool colors is based upon this discrimination. Some colors appear soft (madder-lake), others hard (cobalt green, blue-green oxide), so that fresh from the tube they seem to be "dry."

The expression "perfumed colors" is frequently met with.

The practice was intuitive, empirical and experimental, whereas the theory was prescriptive and absolute. Needless to say, the route taken in the painting is easier to follow than that traced in the theory.

It is puzzling, although in the light of later developments very significant, that for several years after 1901 (when Kandinsky graduated from the Munich Academy) he worked in two quite different and seemingly irreconcilable ways. He painted directly from nature, most

Boris Zvorykin, illustration from a Russian fairy tale.

Kandinsky, *Russian Beauty in a Landscape*, 1905. The imaginative pictures which Kandinsky produced in Munich before he began to suppress the representational elements in his work are full of echoes of Russian legends and folk tales. Kandinsky was proud of his Russian heritage and it may well be that traditional icon painting (in which the subject is not so much the person or event depicted but the spiritual mystery it embodies) was another factor in his decision to introduce abstraction.

Kandinsky, *Painting with Houses*, 1909.

Kandinsky, *Murnau with Rainbow*, 1909.

90

often out of doors, in a late-Impressionist manner, using bright colours which he applied with a palette knife. At the same time, from his imagination he produced decorative, fantastic scenes like illustrations for fairy stories, many of which seem to express his nostalgia for the folk art of Russia. It is as though Kandinsky felt the need both to satisfy the pleasures afforded to the eye and to tell emotionally charged (even sentimental) stories, but he was unable to find a means of doing so simultaneously.

In 1908 he rented a house in Murnau, a village in the Bavarian Alps not far by train from Munich. He spent most weekends and most of each summer there and eventually made the house his principal residence.

Kandinsky was inspired to paint repeatedly Murnau's streets and alleyways, the mountains above it and the churches in the vicinity with their characteristic gilded onion domes. He took ever greater liberties with what he saw. Colours became brighter, seemingly more arbitrary, angles and forms became more exaggerated and even distorted. Objects in nature were increasingly described by means of shorthand lines and forms: a row of roofs was suggested by a zig-zag line, for example, or a mountain by a triangle.

Kandinsky, *Nature Study from Murnau I*, 1909. These three paintings show, albeit in a severely abridged form, the increasing liberties which Kandinsky took with actual, observed motifs as a preparation for the making of paintings free from all conventional methods of representation. The colours are brighter than they are in nature and frequently do not correspond to natural colours at all. The forms are exaggerated or otherwise distorted. Eventually they take on a life of their own. The subjects of all these works show aspects of the Upper Bavarian village of Murnau and of the landscape in which it is situated.

With the benefit of hindsight it is possible to see that Kandinsky was employing a relatively small number of motifs derived from Murnau and its environs in order to establish a basic visual language of lines, colours and forms. He was, literally, 'abstracting' (a word he avoided using), making paraphrases from nature. The elements thus derived seemed to assume an identity of their own.

The mountainous part of Bavaria attracted Kandinsky for its folk art as well as for its scenery. A particular kind of painting produced by the peasants there was made on glass. Intended chiefly for outdoor locations, as votive pictures for wayside calvaries and graveyards, the painted side of the glass was protected from the elements. The image was consequently viewed through the glass itself, thus giving it a jewel-like brilliance and lustre.

Not only the technique fascinated Kandinsky. He was also impressed by the subject-matter and the imagery, which ranged from portraits of saints to the Last Judgment, the Flood and other Apocalyptic scenes. These were similar to the kind of deep, spiritually charged subjects which he wished to paint, although he, of course, wished to paint the meaning without the objects.

Kandinsky himself produced some glass paintings and compositions related to them, using the unnatural colours and shorthand lines and marks which he had evolved in the course of painting his views of

Bavarian glass painting of St Luke, the patron saint of painters, 1800. Painting on the reverse side of panes of glass so as to protect the picture from the elements and enhance the effect of the colours was a technique widespread among the folk artists of southern Central Europe. Such paintings were frequently intended as votive pictures which were fixed to wayside calvaries. This example was reproduced in an important anthology of articles and reproductions, the *Blaue Reiter Almanac*, which Kandinsky edited with his friend Franz Marc and which was published in Munich in 1912.

Kandinsky, *Sancta Francisca*, 1911. This is Kandinsky's first glass painting and it pre-dates most of his work in the medium by several years. It is very faithful in style to Kandinsky's folk art models. His later glass paintings take obvious liberties and depart from the unsophisticated style.

Murnau. Since he felt increasingly free and bold, many of these pictures appear to be almost, or entirely, free from references to nature. None of them is. Careful study of one of them reveals a row of warriors with lances, two warriors on horseback in combat, a castle behind what at first sight appears to be a wild and energetic arrangement of heavy black lines and larger or smaller areas of colour.

It appears that Kandinsky would first choose a subject for its dramatic potential, then radically simplify the major elements in order to

Kandinsky, *All Saints' Day II*, 1911. On the verge of abstraction, Kandinsky increasingly introduced Apocalyptic subjects into his work. Of strong mystical leanings, Kandinsky was convinced that the dawning of a new age was imminent and that abstraction would help prepare the way for it.

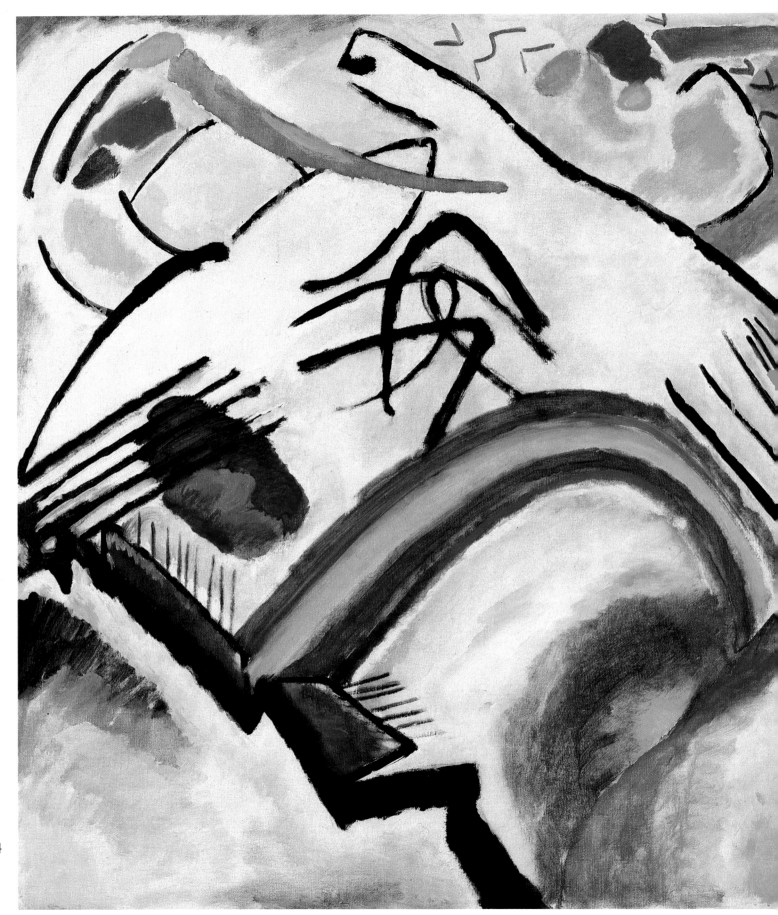

94

Kandinsky, *Cossacks (Study for Composition 4)*, 1910–11.
At first sight an abstract painting, the battle scene from
which its forms and colours were derived can be read
without much difficulty. Kandinsky's own account of the
composition reveals that he was thinking both of a battle
scene and of the effect of the pure colours and forms it
suggested while he was painting.

95

Kandinsky, *In the Blue*, 1925. Kandinsky left Germany at the outbreak of the First World War and returned to Russia via Sweden. In his homeland he was introduced to the radically simple and severely geometric work of Malevich and other Suprematist artists. At least partly as a result of their influence, he suppressed the loose, nature-based lines and forms of his earlier abstract compositions in favour of geometry.

distil or concentrate their characteristics. Thus, the two horses rearing up at each other, their riders swinging scimitars, ceases to be a description of the external facts and becomes the evocation of the forces which the horses and riders express and reveal, of the energy, dynamism and aggression.

Objects continued to provide the basis for Kandinsky's paintings until around 1913, even though they are increasingly difficult to find. Kandinsky did not want them to be found since they were there only as an aid to creation, and to recognize them would be to allow a distraction from the true subject. He therefore gave each of his works a bland title which refers to the way each came about. He called almost everything he produced either an 'Improvisation' or a 'Composition'.

As in music, an Improvisation was the relatively free, spontaneous development of a theme, which could be little more than a fragment, while a Composition was more deliberate, more disciplined and more complex.

When Kandinsky finally made the long-prepared breakthrough into

what he called 'non-objective' painting, the results continued to betray their origins in landscape.

Derived from nature, his language was natural, organic. Many of the paintings are confusing, communicating a strong sense of movement and energy but little else. They certainly do not achieve the elevated purpose Kandinsky intended.

They are, in fact, the unhappy results of a dichotomy in Kandinsky's personality and approach to art. One side of him was highly emotional, subjective. The other side was analytical, scientific. Consequently, he attempted simultaneously to paint in an intuitive, spontaneous manner while constructing objective rules for doing so. In an attempt to cope with the dichotomy, Kandinsky soon changed his style radically, substituting rigorously controlled geometry for the free, nature-based forms of his earlier style.

It should not seem surprising that Kandinsky took so long to arrive at abstraction in his work, nor that his earliest abstract paintings were, even in his own terms, unsatisfactory. It must have taken a great deal of courage single-handedly to jettison the baggage of a thousand years of art history.

Kandinsky worked independently. His was not, however, the only means by which painters in Europe arrived at abstraction before the First World War, nor was he the earliest to do so. In Paris several artists abandoned representation in 1910 or soon after. None of them employed anything like Kandinsky's free, intuitive approach but all developed a clear formal language which could be controlled more easily. Although each of these early French abstractionists worked in an individual style, all of them owed a great deal to the example of Cubism.

CUBISM AND ABSTRACTION

Cubism, the invention of Braque and Picasso in 1908, was decidedly not a kind of abstract painting. Equally decidedly, however, it was not like any kind of painting previously known. Although it set out to represent reality, it construed reality in a highly complex way, and the visually perplexing language of Braque and Picasso evolved from their attempt to solve the insoluble problem (also addressed by Cézanne) of how to transform the rounded, three-dimensional reality of the world in which we live into the flat, two-dimensional reality of the picture surface.

Any illusion of external reality depends, therefore, on a series of conventions by means of which the painter persuades the spectator to believe in a fiction. A Monet hanging on a wall is not a window looking out on to a scene beyond the wall but is a solid object which consists of canvas, paint and wood.

Although an illusionistic painting is a fiction, it is also, as an object in its own right, itself part of reality. The Cubists repeatedly emphasize the fact that their paintings are objects with a flat surface by drawing attention to the surface in various ways.

The confusion caused by the confrontation of illusion and reality

Kandinsky, *White-soft and Hard*, 1932. Like *In the Blue*, this painting was executed while Kandinsky was teaching at the Bauhaus, the German art school which he joined soon after his return to Germany from Russia in 1921.

Pablo Picasso (1881–1973), *Still Life with Chair Caning*, 1912.

was an important part of their work. The most telling example of such confusion used to creative ends is Picasso's *Still Life with Chair Caning*. It consists essentially of three disparate elements: a fragment of a painted Cubist composition, an area of woven cane and a rope attached to the edge of the oval panel on which the picture has been made.

The painted part, so highly stylized that only a fragment of a still life can be made out, is nonetheless a kind of illusion. The marks of paint stand for something else and are intended to be read. At first sight the caning looks real. What is it, if not a piece of the seat of a chair imported into the picture to represent itself? The surprising answer is that it is a piece of waterproof cloth printed to look like caning. Although it is much more convincing as an illusion than the painted still life, it is equally a fiction: no more or less 'real'.

But what of the rope? It is clearly a length of rope, but it acts as a frame. Its twisted strands even look somewhat like the moulding of some conventional frames. Since it acts as a frame, it is by definition a frame. Its function determines its character. Nevertheless it remains a rope.

Such witty manipulation of definitions and different levels of reality is crucial to the point not so much of Cubist painting as of Cubist collage, which is wholly or in part composed of pieces of 'real' material – newspapers, wine labels, fragments of newspaper and so on. Picasso and Braque began to make collages after their Cubist painting became so highly stylized that the few remaining representational elements were almost impossible to recognize. Several Cubist compositions are virtually abstract – in spite of such titles as *Female Nude* or *Still Life with Guitar*. Picasso and Braque were obviously aware of the possibility of abandoning representation completely; but they chose to address problems of reality and representation from another angle by blurring the dividing line between art and life and introducing into their compositions bits and pieces from the 'real' world outside.

If Picasso and Braque did not leap across the gulf between figuration and abstraction which they could clearly see in the most complex of their Cubist paintings, other artists were prepared to try. After all, abstraction was implied in Cubism, not least because Picasso and Braque had always stressed that a painting was ultimately quite independent from nature, an object in its own right.

After using an angular and fragmented style clearly derived from Cubism to paint architectural motifs (especially the Eiffel Tower), Robert Delaunay became increasingly interested in forms for their own sake and in the delights of colour. Fragments of representation remain in Delaunay's prismatic *Windows*, but his series of *Disks* are entirely abstract. Their structure may consist of interrelated circles and curves, and their major expressive vehicle may be bright colour, but their connections with Cubism are clear.

So, too, are the connections between Cubism and the work of another artist living in Paris, Frank Kupka. Kupka, also a colourist, was declared by the critic Apollinaire to be, with Delaunay, a pioneer of a

Georges Braque (1882–1963), *Mandola*, 1909–10.

Robert Delaunay (1885–1941), *Simultaneous Contrasts: Sun and Moon*, 1913. Delaunay's paintings of circular forms are the result of his search for pure equivalents for the different varieties of natural light experienced in nature.

Frank Kupka (1871–1957), *The Disks of Newton*, 1911–12.

new style of painting which Apollinaire called 'Orphism', thus drawing attention to the supposed affinities between music and abstract art.

Another of Apollinaire's Orphists was Fernand Léger, who was also one of the earliest of the Parisian painters to understand what Picasso and Braque were doing and to achieve an individual version of the Cubist style. Influenced by Delaunay, Léger moved away from classical Cubism, first by introducing the primary colours of red, blue and yellow and then by reducing his forms to a small number of more or less elementary shapes. At the same time he began consciously to abstract – from the landscape as well as from the still life and figure. By 1913 the motifs from which the compositions were derived are no longer recognizable. The subject of such paintings is, as their titles make clear, the contrast of form and colour: the round contrasted with the angular, the curved with the straight, the flat with the volumetric.

Fernand Léger (1881–1957), *Contrast of Forms*, 1913.

PAINTING THE FUTURE

The most abstract of Léger's compositions have a regularity that is almost mechanistic, and the application of paint suggests the reflections of light on polished metal cylinders and tubes. The evocation of machines was intentional. Léger was fascinated by technology of all kinds and entranced by mechanics. Believing that the modern world was unthinkable without the machine, he was determined to make his painting relevant to its own age. If the measure of all traditional art was man, it was now, according to Léger, the machine.

Léger was not alone in his enthusiasm for technology and in his determination to paint modern life in a modern way. The new century was scarcely a decade old; since the closing years of the old century inventions which promised radically to change the life of everyone had multiplied; the First World War had not yet cruelly crushed widespread hopes, based on the evidence of science, that human progress was unlimited and unstoppable. How could anything but a totally new kind of art be appropriate to the age of the motor car, aeroplane, radio and telephone?

Significantly, the first painters to proclaim that their art was what the age demanded were not French but Italian, although their work was transformed by the influence of Cubism at a crucial point of their development. Italy had industrialized late, at enormous speed and in a way that was dramatically obvious, especially in the northern cities of Milan and Turin. The psychological effect of the abrupt introduction of the new was sharpened by Italy's unique sense of her own grand, classical past which, according to those artists dedicated to the notion that the new world could only be understood with the aid of a new art, had suffocated all cultural endeavour in Italy for more than a century.

The destruction of all existing art was therefore one of the demands made by the writer F.T. Marinetti in his first Futurist Manifesto published in 1909. Art should reflect and respond to peculiarly modern

experiences: to the city with its teeming crowds of people; to the new sense of space, speed and energy provided by miraculous inventions.

So, with face smeared in good waste from the factories — a plaster of metal slag, useless sweat, and celestial soot — bruised, arms bandaged, but undaunted, we declare our primary intentions to all living men of the earth:

1. We intend to glorify the love of danger, the custom of energy, the strength of daring.

2. The essential elements of our poetry will be courage, audacity, and revolt.

3. Literature having up to now glorified thoughtful immobility, ecstasy, and slumber, we wish to exalt the aggressive movement, the feverish insomnia, running, the perilous leap, the cuff, and the blow.

4. We declare that the splendor of the world has been enriched with a new form of beauty, the beauty of speed. A race-automobile adorned with great pipes like serpents with explosive breath...a race-automobile which seems to rush over exploding powder is more beautiful than the Victory of Samothrace.

5. We will sing the praises of man holding the flywheel of which the ideal steering-post traverses the earth impelled itself around the circuit of its own orbit.

6. The poet must spend himself with warmth, brilliancy, and prodigality to augment the fervor of the primordial elements.

7. There is no more beauty except in struggle. No master-piece without the stamp of aggressiveness. Poetry should be a violent assault against unknown forces to summon them to lie down at the feet of man.

8. We are on the extreme promontory of ages! Why look back since we must break down the mysterious doors of Impossibility? Time and Space died yesterday. We already live in the Absolute for we have already created the omnipresent eternal speed.

9. We will glorify war — the only true hygiene of the world — militarism, patriotism, the destructive gesture of anarchist, the beautiful ideas which kill, and the scorn of woman.

10. We will destroy museums, libraries, and fight against moralism, feminism, and all utilitarian cowardice.

11. We will sing the great masses agitated by work, pleasure, or revolt; we will sing the mutlicolored and polyphonic surf of revolutions in modern capitals; the nocturnal vibration of arsenals and docks beneath their glaring electric moons; greedy stations devouring smoking serpents; factories hanging from the clouds by the threads of their smoke; bridges like giant gymnasts stepping over sunny rivers sparkling like diabolical cutlery; adventurous

steamers scenting the horizon; large-breasted locomotives bridled with long tubes, and the slippery flight of airplanes whose propellers have flaglike flutterings and applauses of enthusiastic crowds.

It is in Italy that we hurl this overthrowing and inflammatory declaration, with which today we found Futurism, for we will free Italy from her numberless museums which cover her with countless cemeteries.

Museums, cemeteries!... Identical truly, in the sinister promiscuousness of so many objects unknown to each other. Public dormitories, where one is forever slumbering beside hated or unknown beings. Reciprocal ferocity of painters and sculptors murdering each other with blows of form and color in the same museum.

Gino Severini (1883–1966), *Suburban Train Arriving in Paris*, 1915.

Quickly joined by painters – among them Umberto Boccioni, Gino

Severini and Carlo Carrà – Marinetti began to think of Futurism as an artistic propaganda machine that would change cultural attitudes throughout Europe and the world.

It was one thing to envisage a new art, another to realize it. The manifestos written by Marinetti himself and Boccioni hum with novel ideas about painting, sculpture and all of life itself as the following passage from the *Manifesto of Futurist Painting* shows:

> *Space no longer exists: the street pavement, soaked by rain beneath the glare of electric lamps, becomes immensely deep and gapes to the very center of the earth. Thousands of miles divide us from the sun; yet the house in front of us fits into the solar disk.*
>
> *Who can still believe in the opacity of bodies, since our sharpened and multiplied sensitiveness has already penetrated the obscure manifestations of the medium? Why should we forget in our creations the doubled power of our sight capable of giving results analogous to those of the X-rays?*
>
> *It will be sufficient to cite a few examples, chosen among thousands, to prove the truth of our arguments.*
>
> *The sixteen people around you in a rolling motor bus are in turn and at the same time one, ten, four, three; they are motionless and they change places; they come and go, bound into the street, are suddenly swallowed up by the sunshine, then come back and sit before you, like persistent symbols of universal vibration.*
>
> *How often have we not seen upon the cheek of the person with whom we were talking the horse which passes at the end of the street.*
>
> *Our bodies penetrate the sofas upon which we sit, and the sofas penetrate our bodies. The motor bus rushes into the houses which it passes, and in their turn the houses throw themselves upon the motor bus and are blended with it.*
>
> *The construction of pictures has hitherto been foolishly traditional. Painters have shown us the objects and the people placed before us. We shall henceforward put the spectator in the center of the picture.*
>
> *As in every realm of the human mind, clear-sighted individual research has swept away the unchanging obscurities of dogma, so must the vivifying current of science soon deliver painting from academic tradition.*
>
> *We would at any price re-enter into life. Victorious science has nowadays disowned its past in order the better to serve the material needs of our time; we would that art, disowning its past, were able to serve at last the intellectual needs which are within us.*

The paintings themselves were not always as exciting as the manifestos, however.

The earliest Futurist works by Boccioni, Carrà and Balla employ the

method of representing light invented by Seurat, and photographs of people and things in movement, to make not always convincing representations of motion and energy.

With the Futurists' discovery of Cubism in 1911 their style changed. They now employed the angularity and imperfect geometry of Cubist composition, and the fragmented, faceted appearance of Cubist representation, to evoke not only speed and dynamism but also what they called the 'simultaneity' of modern life; that is, the way in which experiences of different kinds can bombard the individual on different levels at the same time.

The Futurists were committed to representational art, no matter how highly stylized, and it is perhaps largely for that reason that their art failed to live up to their daring manifestos. Representational art ought in

Giacomo Balla (1871–1958), *Abstract Speed – the Car has Passed*, 1913.

BALLA

their own terms to have been too old fashioned for them.

What might have been possible with the aid of abstraction is demonstrated by the small number of paintings which Giacomo Balla, a relatively late convert to Futurism, made in 1913 and 1914. They are some of the most remarkable examples not merely of Futurism but of all early abstraction. Convinced that speed is best expressed by simple, more or less regular forms, he produced such works as *Abstract Speed – the Car has Passed* in which a few intersecting curves and three colours suggest the noise and eddying shock waves of the vehicle's wake.

The studies of light which Balla called 'Iridescent Interpenetrations' are even more remarkable, anticipating in their regular geometry and subtle progressions of colour something of the Op Art (of which Riley's *Cataract 3* is an example) of half a century later.

ART AND REVOLUTION

For all its manifest weakness as a style, Futurism proved spectacularly influential throughout Europe. For many, Futurism was synonymous with modern art. It was nowhere more influential than in Russia, a country even more backward than Italy and where in 1917 the sense of a new age dawning was immeasurably strengthened by the revolution. In Russia the Futurist programme for the transformation of life and art achieved its logical outcome: not merely abstraction, but abstraction of a particularly radical kind.

Malevich, *Woman with Water Pails: Dynamic Arrangement*, 1913.

106

Futurist ideas and a compositional method derived from Futurism are behind works of peasant subjects such as the *Woman with Water Pails* which Malevich produced in 1913.

At the end of 1915 *Zero-Ten*, subtitled the last Futurist exhibition, opened in Petrograd. There Malevich showed his first black square. It consisted only of a black square on a white square background and was hung in a way which recalled the positioning of an icon in all traditional inns in Russia, where guests would bow to what was not so much an image but the embodiment of divinity as they crossed the threshold. The painting was therefore intended to have a deep spiritual significance.

The paintings Malevich made just before the *Zero-Ten* exhibition are complex and busy by comparison with the ultimate simplicity of the black square. One of them, *Airplane Flying*, consists of regular geometric shapes arranged at the edges of a large triangle. Whatever the spiritual dimension in which Malevich saw works like this, the effect of formal variety and grouping is to create a sense of energy – not unlike the graphic revelation of force fields provided by iron filings attracted to the pole of a magnet. By exploiting the potential of colour to suggest distance and nearness (warm colours appear to advance, cool colours to recede), and by making some of the forms overlap, Malevich also created an illusion of space and of relative distance within it.

Malevich, *Suprematist Composition: Airplane Flying*, 1914.

Airplane Flying, by suggesting movement, energy and space, is in spite of all appearances to the contrary a kind of illusionistic painting. There is no illusionism of that kind in Malevich's black square or in the even more radical paintings which he began to make, appropriately enough, in 1917, the year of the October Revolution. Several of them are called *White on White*, a title that accurately describes their appearance: a regular, white geometric shape against a white background of virtually the same tone. If the black square was intended as a radical gesture, as a symbolic new beginning, what could Malevich have intended by a painting consisting of even less?

Like Kandinsky, Malevich was an indefatigable theorist. Unfortunately, as has already been pointed out in a previous section, his attempts to explain how his work possessed a spiritual dimension are even less easy to understand than Kandinsky's metaphysical meanderings. Suffice it to say that the squares and crosses in Malevich's exceedingly simple paintings are images for contemplation. Like the face of the Madonna in an icon, they have the power to transport the viewer to another plane.

Whether or not Malevich's white paintings work in the way he intended, they have fascinated several later generations of painters because of the daring required to make them and because they do exist at the ultimate limits of painting. An art object consisting of anything less can scarcely be imagined.

Once he had achieved the mature style of which *Composition with Blue and Yellow* (discussed in Part One) is an example, Mondrian, whose simple visual language looks positively Baroque beside Malevich's *White on White*, continued to paint in more or less the same way for the rest of

Bart van der Leck (1876–1958), *Study for Arabs on Donkeys*, 1915.

Van der Leck, Study for Composition 1917 No.5 (Donkey Riders).

his life. Malevich's gesture was too radical, his language too simple to enable him to do the same and keep his sanity. He had painted himself into an impasse; but instead of working back towards a more complex abstract language, he abandoned abstraction entirely and became a figurative painter once again.

Another kind of simple, purely geometric abstraction was produced in Russia while Malevich was developing his Suprematism. It, too, was the work of artists who had been crucially influenced by Cubism and Futurism, but, unlike Suprematism, it made no spiritual or metaphysical claims. On the contrary, it saw a geometric abstract language as the symbol of reason, logic and the modern age. It was the creation of such artists as Vladimir Tatlin, Alexander Rodchenko and Naum Gabo. They called themselves 'Constructivists' and saw themselves as the artistic equivalent of scientists experimenting in a laboratory.

None of the Constructivists was purely a painter. Most of them concentrated on sculpture, a medium which they transformed by using unconventional materials in unconventional ways. All envisaged a world in which neither painting nor sculpture would exist as such: art itself would be absorbed by architecture, science and engineering. The artist would become a kind of engineer, constructing functional images.

It is striking that each of the early forms of abstract art was in part a reflection of a longing for social or spiritual renewal, or both. In Russia the Suprematists and Constructivists actively worked for the State during the period immediately following the Revolution. With an optimism which now seems touching but naive, they tried to convince the mass public of the virtues of abstraction and of the revolutionary nature of its language.

Naum Gabo (1890–1977), *Model for Rotating Fountain*, 1925 (reassembled 1986).

DE STIJL
In Western Europe, cut off from the War in neutral Holland, Mondrian also believed in the Utopian, reformist implications of his new, abstract language. He, too, had been crucially influenced by Cubism.

Van der Leck, Study for Composition 1917 No.6 (Donkey Riders).

Gerrit Rietveld (1888–1964), *Red and Blue Chair*, 1918. In 1919 Rietveld wrote of this, the most celebrated *De Stijl* object: 'With this chair an attempt has been made to have every part simple and in its most elementary form'.

Although Mondrian worked independently before the War in Paris and, until 1917, in his native Holland, he later came into close contact with a number of artists and architects who were exploring a similarly simplified and geometric language derived from natural motifs. Chief among the painters were Theo van Doesburg and Bart van der Leck. In 1917 the former launched an artistic journal called *De Stijl*, which means nothing more portentous than 'The Style' – although the definite article should probably be stressed in order to convey something of Van Doesburg's messianic conviction. What he and his fellow contributors were creating was, in their view, nothing less than the definitive art form of the future.

De Stijl was unthinkable without Mondrian. He showed the others how versatile a relatively simple geometric language could be; and he also made the first pure abstractions without deriving his imagery or compositions from nature.

De Stijl was neither a journal nor a group primarily concerned with painting. Rietveld, a designer and architect, was a member, as were the architects Oud, Wils and Van't Hoff. Van Doesburg, himself an architect and designer as well as a writer and painter, advocated a universal language for every fine and decorative art form (including furniture) – the right-angle and primary colours – and envisaged a glorious moment when painting would be completely absorbed by architecture.

Van Doesburg's vision – the entire world transformed into a piece of *De Stijl* architecture – was something Mondrian was unable to share. He was equally unable to accept Van Doesburg's demand that the visual vocabulary of the *De Stijl* language should be broadened to include the diagonal line. For Mondrian the diagonal was a vital, restless element inimical to the harmony of opposites he was striving to achieve in every composition.

The dispute between Van Doesburg and Mondrian which resulted in Mondrian's resignation from *De Stijl* may seem like high farce – all that fuss about a diagonal line! But it at least reveals the strength of the passions inspired by abstraction. Quite sensible, highly intelligent men regarded art with the seriousness with which others regarded morality or religion.

While Mondrian and Van Doesburg were arguing about diagonal lines, abstraction was losing some of its charm for many advanced artists. By 1925, apart from *De Stijl*, the only important concentration of abstract painters was among the teaching staff of the Bauhaus, the German art school based until 1925 at Weimar and then Dessau. The staff included Kandinsky, who had abandoned his free style based on natural forms for a more disciplined, geometric manner, and Moholy-Nagy, the Hungarian Constructivist who also, of course, worked exclusively with regular, geometric shapes. Klee taught there, too, although only a very few of his paintings can properly be described as abstract.

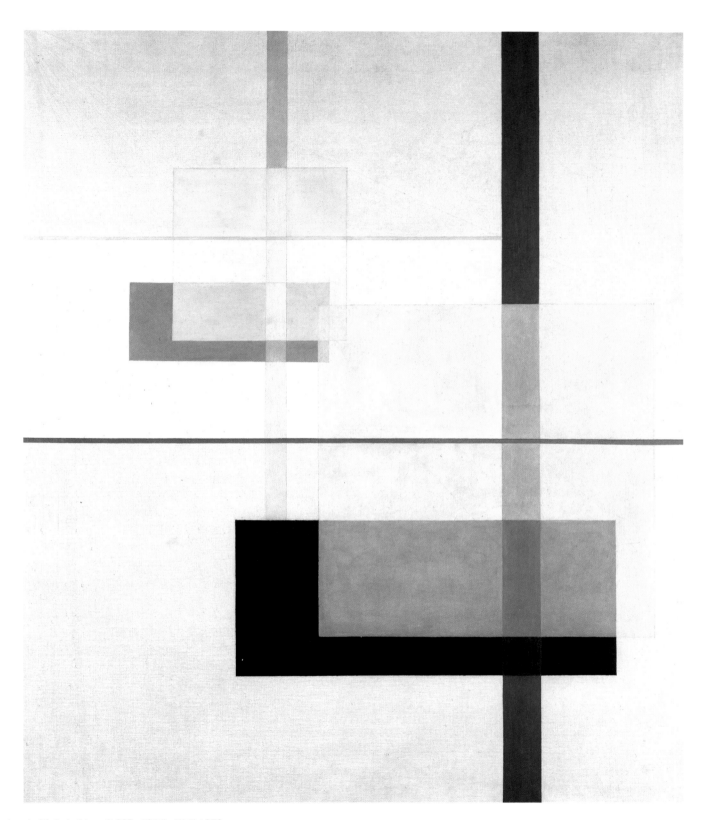

Laszlo Moholy-Nagy (1895–1946), *K VII*, 1978.

ABSTRACTION AND THE SUBCONSCIOUS

Elsewhere, most artists rejected the claims of abstraction, preferring figuration of one kind or another. Most of that figuration was conservative: artists cultivated tried and trusted values instead of experimenting. Before the First World War the Futurists had advocated destroying the museums and everything in them. Now artists studied the Old Masters again, borrowing their subjects and emulating their styles.

The major exception to this general conservatism was the movement which began in Paris in the early 1920s. The creation of the writer and critic André Breton, the movement was called 'Surrealism', although 'Super-realism' would be a better English translation, conveying as it does Breton's search for a reality higher than – superior to – that which is commonly regarded as real.

Breton was greatly influenced by Freud's theories of the human psyche which hold that the mind consists of three layers, the most important of which is the 'id', or subconscious. It is there, secretly, that the instincts work, usually kept under control by the conscious mind and the conscience. Breton believed that super-reality could only be apprehended with the aid of the unconscious; but for him (as indeed for Freud), the problem was how it might be liberated, brought out from the dark, so to speak, into the open.

One key was provided by chance. For Breton the writer, chance was invoked by cutting out words and sentences at random from books and magazines, mixing them up and reassembling them, again at random. More often than not the result would be unintelligible. Occasionally, however, a phrase, image or sentence would appear which in its very unexpectedness triggered the imagination. Similarly unpredictable results occurred when a game like that of Consequences was played. A single phrase or line of verse was composed by each participant and consigned to a slip of paper. No-one knew what the others had written until the end when, with luck, some extraordinary, evocative juxtapositions had occurred. Once, the phrase 'The exquisite corpse drinks the new wine' appeared. It was so memorable that the game itself became known as 'Exquisite Corpse'.

The painters who joined Breton looked for parallel methods of using chance to create visual images. Max Ernst, for example, made collages from details cut from engraved book and magazine illustrations. He also made rubbings of pieces of textured wood and other hard materials before looking at the results for suggestions of strange pictures. André Masson was but one of several Surrealists to employ automatic drawing. In a trance-like state, induced sometimes by alcohol or drugs, he would scribble aimlessly before some coherent image would be suggested by the random marks.

There was, of course, nothing new about such methods of stimulating the imagination. Centuries before, Leonardo had advocated staring at marks on walls and rough tree bark as a creative tool. It must also be stressed that the aim of Surrealists such as Ernst and Masson was

Max Ernst (1891–1976), 'There remains then he who speculates upon the vanity of the dead, the spectre of repopulation', a collage illustration from *La Femme 100 Têtes*, 1929.

to create recognizable, figurative imagery and to have nothing to do with abstraction.

Miró, one of the leading Surrealists, did produce some purely abstract paintings, however, and a great many more which negotiate the narrow border between abstraction and figuration. By using abstract forms together with descriptive images, he was able to create a personal world in which the viewer's imagination can run riot.

It might indeed be said that the clearer the descriptive imagery the less room there is for the imagination. By employing abstraction, Miró could exploit allusion and ambiguity.

Miró's abstract language is, of course, quite different from that of Mondrian and Malevich. Decidedly non-geometric, it is irregular and organic; that is to say, it assumes the forms of living, growing things. The early abstraction of Kandinsky was also organic; but by the 1920s he had adopted a more geometric language for his compositions. Apart from Miró, Masson and the other Surrealists interested in exploiting the

André Masson (born 1896), *Automatic Drawing*, reproduced in *La Révolution Surréaliste*, No. 3, 1925

113

ambiguity of organic forms, geometry dominated abstract painting until after the Second World War.

The growth of abstraction before 1920 was spectacular and may give the impression that all the most gifted painters quickly abandoned the use of recognizable subject-matter in their work. Nothing could be further from the truth. In France, Picasso was unpersuaded by the claims of abstraction. Even in Germany, where, it might be argued, the metaphysical claims of abstraction fell on sympathetic ears, figurative artists continued to be in the majority and controversies were frequently sparked off in the art press about the feasibility of abstraction.

Indeed, after the First World War there was a marked swing not only against abstraction but against experimental art of every kind. Previously *avant-garde* artists now praised the virtues of conservatism. Versions of Classicism, of Realism and Naturalism became as popular in Europe as they did in the United States.

One of the results of this reaction to the years of headlong experimentation before 1914 was that those abstract painters who stuck to their principles now felt threatened and obliged to explain what they were doing and why they were doing it. It was not enough to claim that an abstract painting was fundamentally a decorative arrangement of shapes and colours. It had to be demonstrated that it was not simply as valid but actually more valid than art with recognizable subject-matter. No accusation could be more calculated to provoke apoplexy in the abstract painter than the assertion that what he was doing was comparable to the design of fabrics or wallpaper.

The pioneers of abstraction whose work has been considered here wrote at length about their work. Their writing is not always easy to understand and is often confusing, revealing, it might be said, both a woolliness of thought and a determination to convince not only an audience of the validity of abstraction but also the artists themselves.

It cannot have been easy to have been an abstract painter during these early days. Kandinsky, Mondrian and Malevich must have been nagged repeatedly by doubts. A sympathetic audience for their work was never large. In the Paris of the 1920s, for example, there was such enmity between the abstractionists and the Surrealists that scuffles between members of each group frequently broke out on the street.

PART THREE

ENVOYING ABSTRACT ART

There was an element of play-acting in the skirmishes which took place in Paris between the Surrealists and the abstract artists during the 1930s – they even dressed in ways which advertised their affiliations. From the very beginning abstract art attracted notice and inspired strong feelings. A few artists and members of the public felt that it was the only art form possible. Many more were convinced that abstraction resulted in an impoverishment of traditional forms and that the artists were deluding themselves about the potential of a purely visual language.

Certainly there is a degree of wishful thinking if not self-delusion in the theories which many abstract artists have formulated as much to convince themselves as their public of the validity of what they were doing. There is an obvious, and in places enormous, gulf between the claims which Kandinsky made for abstract painting and the way in which his own abstract paintings affect the people who look at them. Few people find themselves stimulated by Mondrian's work either to conduct an inner, philosophical discourse or to apprehend that state of harmony on which a better world was thought to depend.

Understanding the artist's intention is an important step in appreciating and judging any work of art. There may be clues to this in the work itself, or in the title, if not explained in a comprehensible manner in the artist's writings. Only when the viewer has gained an idea of what the artist meant to do, the effect he wanted his work to have, is he in a position to judge the degree to which the artist has been successful.

This process may very well depend on mental comparisons with other similar and dissimilar work. No artist works entirely in a vacuum; no viewer does so either. The more he has seen, the more reliable are his standards of comparison. Experience, intelligently ordered memories, make looking at a work of art a potentially enriching experience.

Not every work of art will actually enrich, however. Some that the viewer may come across, even in the major museums, are downright bad, affording the eye little excitement and the mind little stimulus.

Bernardino Luini (*c.* 1485–1532), *Head and Shoulders of a Young Woman*, early sixteenth century.

Below: Leonardo da Vinci (1452–1519), *Madonna of the Rocks*, late fifteenth century.

What, therefore, are the differences between a good and a bad abstract painting?

Given the variety of abstract styles and the variety of possible intentions, few rules can be given. If the artist has clearly set out to make colour his major means of expression and the colour seems dull and uninteresting, then the artist has failed. Similarly, a painting which clearly relies on the careful disposition of shapes for its effect is not successful if it seems to the viewer to be badly composed. Such judgements may be fundamentally subjective, but experience plays a part, too.

Experience enables other judgements to be made. There is, for example, the question of originality. Although only modern artists have made a fetish out of originality, it has always been important, and artists who have managed to introduce new elements into their work have always been especially admired. If a work by such an innovator as Leonardo da Vinci, for example, is compared with one by a disciple, even such a gifted disciple as Bernardino Luini, it becomes clear that Leonardo's very originality, his fight to solve new pictorial problems and the freshness of the solutions, has resulted in a better painting. If anyone

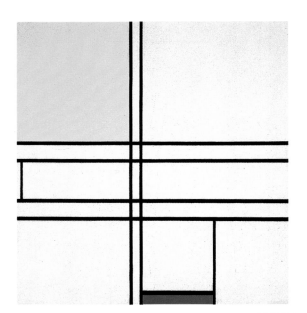

Mondrian, *Composition with Blue and Yellow*, 1935.

Verena Loewensberg (born 1912), *No. 50*, 1942.

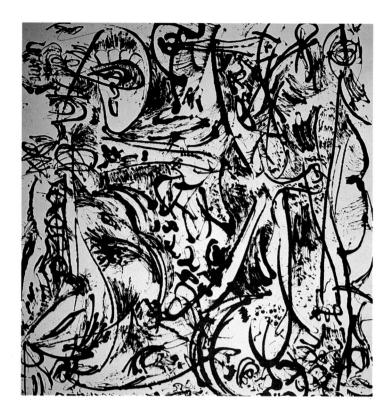

Pollock, *Echo (No. 25, 1951)*, 1951.

Congo the chimpanzee.

exists who knows the work of Luini but not that of Leonardo, he will experience something of a shock when he is finally confronted by the paintings of the greater and more original master.

The same is true of abstract art. Mondrian continues to inspire artists to follow his example and their work, instantly recognizable, inevitably invites comparison with (in all senses) the original. Those of Mondrian's followers, such as Verena Loewensberg, who have injected original elements into the Dutchman's spare language are better artists than the slavish copyists but they are nevertheless not as good as Mondrian.

As soon as Jackson Pollock's work became famous and his unconventional methods widely known, artists everywhere did their best to discover similarly novel ways of making pictures. Bicycles were ridden through pools of paint and then across the canvas. Balloons filled with paint and hung in front of a blank canvas were burst with the aid of an air rifle. Naked models covered with paint were encouraged to writhe about on canvas placed on the floor.

The practitioners of the more spectacular varieties of Abstract Expressionism are now forgotten. Even in the short run, their work came to seem shallow by comparison with Pollock's painting. They were obviously concerned only with superficial appearances while he expressed a sincere and deeply felt attitude not only to art but to life itself.

At the height of the fashion for Abstract Expressionism the style was repeatedly attacked for its seeming randomness and mindless lack of

119

control. Painting chimpanzees were introduced to a gleeful public in the United States and Britain. Their work, it was said, bore comparison with that of Pollock.

It is, however, obvious that any comparisons are so superficial as to be meaningless. But they do make it clear that Pollock, far from relying only on chance while painting his pictures, exercised a high degree of control. Congo's 'paintings' are daubs: there is a monotony about the kind of mark he made and a lack of discrimination about the colours he used which reveal a lack of intelligence. Pollock's works by contrast are carefully considered.

Some, of course, are better than others – and one of the greatest pleasures provided by looking at pictures is a growing confidence in the ability to make such judgements.

The first step, as has been said, is to try to discern the artist's intentions. In the past the intentions of most artists were identical to the expectations of their public. Artists knew what the public wanted and gave it to them.

During the nineteenth century some artists became alienated from their public. For a variety of reasons, both economic and social, some artists came to despise the mass of the population and to see themselves as especially gifted and privy to important truths. No longer interested in giving the public what it wanted, they were determined to work only to their own standards. They were convinced that, although rejected by their contemporaries, they would be vindicated by posterity. It was not so much that they set out to provoke and annoy, rather that they were not prepared to compromise their beliefs for the sake of money or fame.

"His spatter is masterful, but his dribbles lack conviction."

Most important artists to this day paint primarily for themselves. It does not follow that the viewer looks at such works without profit. If he can accept the standards to which the artist has worked and the idea that a painting cannot be judged in the same way as a teapot or a chair, he can derive more from such an art work than from one which meets his expectations and satisfies his wishes. Imagine how dull life would be without surprises, challenges and new ideas!

It follows that the viewer has to contribute something himself if he is to derive anything from looking at an abstract painting. But the viewer has to contribute something in the case of every work of art if he is to get much from it. It is possible to admire Titian's *Diana and Actaeon* for its masterly depiction of flesh and evocation of drama. Knowledge of the myth which it illustrates (Diana turned Actaeon into a stag after he saw her naked and he was torn to pieces by his own hunting dogs) transports the appreciation of the painting's purely aesthetic qualities into a different, higher dimension.

Titian (*c.* 1487–1576), *Diana and Actaeon, c.* 1559.

121

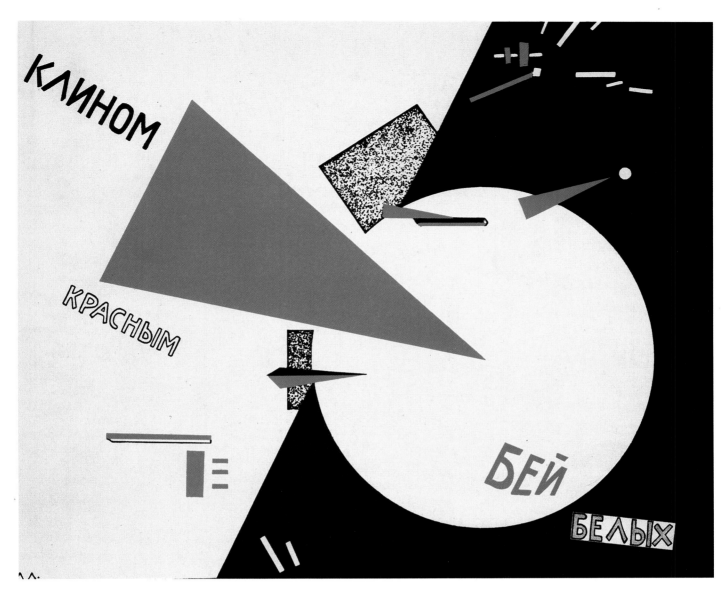

What the viewer contributes to an abstract painting is not so much knowledge as time and, frequently, something of himself. Mark Rothko's paintings, for example, are intended to be objects for contemplation. They set out to persuade the viewer to look into himself.

Some people claim that paintings such as those by Rothko have a message and, indeed, many abstract painters have made such a claim about their own work. From time to time artists have set out to change the world, believing that images can affect the way people think and feel. Russian revolutionary painters not only thought that abstraction embodied a political view of the world (a new society demanded a new visual language free from all illusion and pretence) but they occasionally tried to express specific messages with the aid of an abstract language. The best-known example of this is El Lissitzky's poster attacking the reactionaries, *Beat the Whites with the Red Wedge*.

El Lissitzky (1890–1941), *Beat the Whites with the Red Wedge*, 1919–20. This poster, a piece of Bolshevik propaganda, employs bold abstract language in its message of opposition to the 'White' counter-revolutionaries.

Mark Rothko (1903–70), *Red, White and Brown*, 1957.

Surely no-one would be converted to the Bolshevik cause by looking at this. Nor would the contemplation of a Mondrian transform the viewer into a Utopian Neo-platonist. What is more, many abstract pictures are intended simply to be looked at and to have an exclusively visual effect.

The best art, figurative as well as abstract, broadens the viewer's experience and enhances the quality of life because it gives him more to enjoy and appreciate. It may sound like an inflated claim, but millions derive pleasure from looking at and moving around in the English countryside because John Constable's paintings revealed and defined its beauties. Abstract paintings can also uncover areas of visual pleasure which may previously have been unseen and unappreciated. In the broadest panorama, as in the smallest spot of nature, relationships of form, effects of colour and texture can be found which delight the eye. A good abstract painting will educate the viewer to see more of them. That is the only important message abstraction in general needs.

Time and time again questions are asked of abstraction which can be asked with equal urgency of all art. One of the most common is: does an abstract painting require more or less skill in its execution than a traditional work? The answer is possibly frustrating: it depends on the abstract painting.

The degree of skill manifested in a work of art was at one time an important criterion: the words 'artist' and 'artisan' used to be synonymous. Skill enabled the artist to produce convincing illusions of reality and also to produce a well-crafted piece of work. In the nineteenth century the art-buying public looked for a relationship between the amount of labour obviously invested in a picture and the price. The Pre-Raphaelites slaved away, lovingly refining every detail and bringing the whole work to a high finish. Their patrons were happy to pay for the results of such honest and skilful toil just as they were prepared to pay for ornate decoration on furniture and on the interior and exterior of buildings.

The new type of artist, painting primarily for himself, was less convinced of the value of skill and craftsmanship for their own sake. It was the effect that mattered and, if it could be achieved quickly, then so much the better.

The most celebrated example concerning the conflict of views of the importance of skill as traditionally conceived is provided by the trial of John Ruskin for libel. The case was brought in 1878 by Whistler against Ruskin. After Whistler had revealed that he had charged two hundred guineas for the painting which had provoked Ruskin's wrath, a picture which had taken two days in the making, the critic's counsel asked: 'The labour of two days, then, is that for which you ask two hundred guineas?' To which Whistler replied: 'No. I ask it for the knowledge of a lifetime'.

Although the verdict was for Whistler, the jury expressed a clear opinion about his art by awarding a mere farthing in damages. By ordering the painter to pay his own costs, the judge was evidently of the same opinion.

The importance of skill and finish has remained a problem ever since. The Impressionists were attacked for leaving their work unfinished and Picasso is not the only artist to have been accused of drawing no better than a child.

In fact the degree of manual skill required by an artist has always depended on his intentions. Some artists have tried to draw like children and most of them have been forced to realize how difficult a task it is.

Some types of abstraction require great skill and an accomplished technique. The colour in a Barnett Newman is the result not of a single coat casually applied but of several layers, often of different hues, each of them brushed on to the canvas in a way which helped the artist achieve the subtle variations of the rich saturated colour he desired.

Similarly, Mondrian took pains to cultivate the hard, creamy appearance which, with its appeal to the sense of touch, contrasts with the seemingly mathematical precision of his compositions.

Most abstract painters are as concerned about the technical aspects of their work as was any Old Master. If they use acrylic, rather than oil colours, it is because only in acrylic can they create the effects they want. And they know and exploit the differences between the visual qualities of paints produced by one manufacturer and another.

Such subtle distinctions are crucially important to artists producing pictures the point of which is entirely visual. The beauty of a painting by Morris Louis is largely the result of a technical consideration. Instead of working on a canvas sized and primed to make it non-absorbent, he painted directly on to raw cotton duck so that the colours, acting like a dye, became atmospheric, even evanescent.

Technical skill and manual dexterity were important even for Jackson Pollock, whose work seems to some to be the epitome of sloppy craftsmanship. In spite of the critical gibe embodied in the nickname 'Jack the Dripper', he spilled, threw and spattered his paint with a control which, paradoxically, invited accident and even directed it to an extent which made it something willed.

The more one thinks about abstract painting, the less it seems distinct from representational art. Looking at it and enjoying it is an exercise no different from looking at a figurative work. If figurative painters have affected the way we see the world, so too have abstract artists. Mondrian has repeatedly inspired the designers of dresses and packaging. Architects have repeatedly employed spatial relationships and formal arrangements first suggested by abstract painters.

Abstract art approached with an open mind can suggest entirely new ways of seeing. Knowledge, of the painters' ideas and intentions, experience, gained from looking at pictures, and open-mindedness: these represent the viewers' contribution, the key to forming judgements and enjoying abstract art.

Larry Poons (born 1937), *Zorns Lemma*, 1963.

OP ART

The vibrations set up by juxtaposed complementary colours are not real. They are optical illusions. The creation of such illusions is the main aim of Op Art, a variety of abstraction named to draw attention to the optical nature of its effects.

One of the best-known Op artists is the English painter Bridget Riley, who exploits very subtle arrangements of colour as well as the more obvious complementaries in order to affect the eye powerfully with illusions of energy, vibration and other kinds of movement.

Colour is an important device in most Op Art, but so is form. Geometric elements carefully arranged are as important to the Hungarian Victor Vasarely (a pioneer of Op Art) as is colour – indeed many of his works use only black and white. The illusion of pulsating movement in his work is most often created by the ambiguous relationship between figure and ground (negative and positive shapes) and the subtle changes which a series of geometric forms is made to undergo.

It is impossible to imagine a variety of Op Art which is non-geometric, for every example of Op Art must be the result of careful planning and deliberation, to say nothing of a knowledge of perceptual psychology. In spite of the scientific air which hangs around Op Art, the best examples of this kind of abstraction go beyond the mere illusion of vibrations or other movement (which would be little more than a gimmick) to evoke a mood or even to suggest natural phenomena such as the changing patterns of light and shade on the wind-ruffled leaves of a tree or sunlight dancing on the surface of water.

Geometric, controlled and intellectually rigorous, Op Art has its roots in Constructivism and can be seen as the realization of Malevich's aim to achieve 'the supremacy of pure sensibility in art'. Paradoxically, however, it is also the abstract style closest in intention to figuration. A figurative painting tricks the eye into seeing something – a figure or some other object that is not really there. Illusion is also the point of Op Art.

Victor Vasarely (born 1908), *Supernovae*, 1959–61.

HARD-EDGE PAINTING

The colour-field painting of Poons shares with Op Art the use of complementaries and other juxtaposed colours to create certain visual effects. Hard-edge painting is also like Op Art in certain limited ways, above all in its exploitation of ambiguity.

As its name implies, hard-edge painting employs clearly defined forms, most often a single, clear-cut shape. The colour of that shape and of the ground are carefully chosen so as to create tension between both and frustrate all attempts to read the painting as a figure against a background.

The American Ellsworth Kelly is the leading practitioner of hard-edge painting. Sometimes, as here, he will use a single, regular shape placed more or less centrally on the canvas. More often, the major form will be eccentrically positioned so that the edges of the canvas play a part in the composition and it is more difficult to distinguish between figure and ground. The colour in Kelly's work is always bright and his paint surfaces are always hard and glossy: no trace of brushwork, no hint of the artist's personality are allowed to interfere with the visual effect of the colour.

Although the forms of hard-edge painting are geometric, Kelly's inspiration is often provided by nature – as his precise outline drawings of leaves and other organic forms show. Kelly was once heavily influenced by Constructivism and there is an obvious connection between the simple compositions and anonymous surfaces of hard-edge painting and those of such Russians as Malevich. There is, however, an equally obvious connection between hard-edge painting and the paper cut-outs of Matisse, in which the effect of colour is enhanced by confining it to single, clearly defined areas.

Ellsworth Kelly (born 1923), *Red-orange Blue*, 1964–65.

SHAPED CANVAS

The loyalty of painters over centuries to the rectangular shape is one of the most remarkable – and puzzling – phenomena in art history. The use of the oval by Picasso and other Cubists, and Mondrian's occasional use of a square turned through ninety degrees to produce a lozenge, are two of the unusual devices employed by modern artists to get away from the restrictions imposed by the rectangle and exploit the new compositional opportunities thus opened up.

Some artists have used unconventional formats to destroy the distinction between painting and sculpture. The Russian Constructivist El Lissitzky, for example, made paintings in several parts which, arranged at angles to each other, invade the space around them. They are neither paintings nor reliefs but share qualities with both.

Paintings can be shaped in a variety of ways. They can be flat with shaped edges: they can use canvas stretched over unusually shaped wooden frames in order to produce curves. In every case, the unusual format draws attention to the fact that the art work is first and foremost an object in its own right, something to be viewed primarily as a visual statement.

It is the literalness of the art work – that the painting is what the viewer encounters and nothing more – that the American Frank Stella sought to emphasize in his shaped canvases.

He began by using a conventional format – a square or rectangle – which he covered with a regular, simple geometric pattern echoing or harmonizing with the proportions of the canvas. He would make closely spaced diagonal lines meet at the centre of a square or simply arrange them to run at equal intervals from top to bottom.

In most of these paintings Stella used only black, and the paint itself was of an unusual metallic variety so as to create a hard, thick surface with a dull sheen. Without the seductive appeal of colour or the visual variety afforded by a complex composition or structure, Stella's pictures proudly (if somewhat tiresomely) proclaimed their identity. Not only were they not illusionistic, they did not pretend to any metaphysical or transcendental significance either. Their entire point was the generation of an impersonal image by following the form of the canvas itself.

The potential of such a rigid approach was extremely limited. Stella increased the potential enormously by working on unusually shaped canvases, the edges of which continued to dictate the forms within. He employed not only parallelograms and shapes like the letter Z, but also arrows and other forms.

There is a negative streak to Stella's work: what it is not is as important as what it is. It is not a highly personal emotional statement of the Abstract Expressionist variety; it does not trick the eye into believing in the existence of something that is not there; it does not allude to anything outside itself. It is abstraction of the most complete kind, in its way as extreme (and as much of a dead end) as Malevich's white-on-white paintings.

Frank Stella (born 1936), *Itata*, 1964.

MINIMAL ART

Terms such as 'gestural', 'hard-edge' and 'minimal' are helpful but they can be confusing. The more impressive a painting, the less susceptible it is to adequate description by a single word or phrase. That is one reason why most artists are unhappy to find their work categorized in that way.

None of the categories mentioned here is exclusive. Some colour-field painting is also Abstract Expressionist. Some types of organic abstraction are also Surrealist, while Op Art is obviously a kind of geometric abstraction.

Since Kelly's hard-edge painting employs very few elements, relies indeed for its major effects on the conjunction of two or three simple forms, it can also be described as an example of minimal art, a phrase applied to highly simple varieties of abstraction.

A better example of minimal painting is the shaped canvas by Frank Stella that has already been discussed, for it is not only highly simple and economic but also clear, regular and intentionally banal, avoiding every kind of complication and allusion.

The almost monochrome painting by the American Ad Reinhardt exemplifies yet another type of Minimalism, although Reinhardt was working in this way a decade or more before the phrase 'minimal art' was coined. Reinhardt's monochrome paintings, in which a single geometric form or a series of geometric forms identical in shape and size are placed at regular intervals on a ground of almost identical colour, irresistibly invite comparisons with Malevich's work. Reinhardt even used a black square on a black ground from time to time.

Yet Reinhardt's style owed little or nothing to Malevich and was rather an extreme development of Cubist abstraction and, later, of colour-field painting. Like Rothko and Newman, he envisaged an art that would be eloquent in its simplicity, absolute in its directness. Unlike them, however, he suppressed sensuous, vivid colour and avoided the use of atmospheric, suggestive brushwork.

Reinhardt greatly admired Oriental art, especially those kinds such as Zen Buddhist painting which strive for heightened expression in extreme simplicity. In an article of 1960, he described the qualities of Oriental art he sought to emulate: 'Only blankness, complete awareness, disinterestedness; the "artist as artist" only, of one and rational mind, "vacant and spiritual", empty and marvellous; in symmetries and regularities only; the changeless "human content", the timeless "supreme principle", the ageless "universal formula" of art, nothing else.'

144 Ad Reinhardt (1913–67), *Black on Black No.8,* 1953.

APPENDIX

CHRONOLOGY

1908 Braque and Picasso execute first Cubist works
Kandinsky rents house at Murnau, Bavaria

1909 Publication of first manifesto of Futurism by Marinetti in *Le Figaro*

1910 Publication of *Manifesto of Futurist Painting*
Kandinsky, Léger and Kupka exhibit at *Salon d'Automne*

1911 First *Blaue Reiter* exhibition in Munich
Exhibition of Futurist works tours Europe
Mondrian goes to Paris

1912 Publication of *Blaue Reiter Almanac* edited by Kandinsky and Marc
Publication of *Concerning the Spiritual in Art* by Kandinsky
Reference to Orphism by Apollinaire in describing the work of Delaunay and others at the *Salon d'Automne*

1913 *Victory over the Sun* performed in St Petersburg with décor and costumes by Malevich

1914 Outbreak of First World War
Kandinsky returns to Russia
Marinetti lectures on Futurism in Russia
Mondrian returns to the Netherlands

1915 *Zero-Ten* exhibition in Petrograd (St Petersburg), where Malevich shows *Black Square*

1916 Beginning of Dada in Zurich

1917 Foundation of movement and publication of first issue of *De Stijl*
Beginning of Russian Revolution

1918 Van der Leck leaves *De Stijl*

1919 Mondrian moves to Paris
Publication of essay 'Natural Reality and Abstract Reality' by Mondrian
Establishment of Bauhaus at Weimar

1920 Publication of *Neo-Plasticism* by Mondrian
Publication of essay 'Creative Credo' by Klee
Publication of *Realist Manifesto* by Gabo and Pevsner

1921 Kandinsky leaves Russia
Klee joins staff of Bauhaus

1922 Kandinsky joins staff of Bauhaus
Exhibition of contemporary Russian art in Berlin organized by Moholy-Nagy

1923 Moholy-Nagy joins staff of Bauhaus
Schwitters publishes first issue of *Merz*

1924 Mondrian ceases collaboration with *De Stijl*
Publication of first manifesto of Surrealism by Breton

1925 Bauhaus moves to Dessau
Publication of *The Pedagogical Sketchbook* by Klee
First exhibition of Surrealism in Paris
Publication of *The New Vision: from Material to Architecture* by Moholy-Nagy

1926 Publication of *Point and Line to Plane* by Kandinsky

1927 Publication of *The Non-Objective World* by Malevich

1929 Foundation of *Cercle et Carré* group in Paris

1931 Foundation of *Abstraction–Création* group in Paris

1932 Bauhaus moves to Berlin

1933 Closure of Bauhaus by Nazis
Klee moves from Germany to Switzerland
Kandinsky moves from Germany to France

1935 Inauguration of Works Progress Administration (WPA) – Federal Art Project
Foundation of The Ten group in New York

1936 Foundation of American Abstract Artists group in New York

1937 Nazi *Degenerate Art* exhibition
Circle produced in England by Nicholson, Gabo and Martin

1938 Mondrian moves to London

1939 Outbreak of Second World War

1952 First reference to Action Painting in an article by Rosenberg

1960 Foundation of *Groupe de Recherche d'Art Visuel* in Paris

1940 Mondrian moves to New York

1964 Op Art exhibition *The Responsive Eye*, Museum of Modern Art, New York

ARTISTS' BIOGRAPHIES

ARP, Jean (Hans). 1887–1966
French. Born Strasbourg; died Basel. Sculptor, painter and poet. Studied in Strasbourg, Paris and Weimar. Founder member of the Dada movement in Zurich, 1916. Experimented with cut-paper compositions, collages and made his earliest abstract reliefs. Associated with the Surrealists in Paris, contributing to first Surrealist exhibition, 1925. Member of abstract group *Cercle et Careé* and co-founder of *Abstraction–Création* in Paris, 1931. Lived at Meudon, near Paris, 1926–40, and returned there after 1946. Leading exponent of organic abstraction, his pictorial language evoking natural forms.

BALLA, Giacomo. 1871–1958
Italian. Born Turin; died Rome. Studied in Turin. Settled in Rome, 1895. Visited Paris, where he was impressed by the work of Seurat and Signac. Signed *Manifesto of Futurist Painting*, 1910, though his work in a true Futurist style dates only from 1912. Series of studies of speeding motor cars, 1912–13. Progressed to painting in a more abstract manner, 1913–16. Studies of light, *Iridescent Interpenetrations*, anticipated Op Art.

DELAUNAY, Robert. 1885–1941
French. Born Paris; died Montpellier. Apprenticed to a decorative painter. Influenced by Seurat and Neo-Impressionism, 1910. Exhibited at first *Blaue Reiter* exhibition in Munich, 1911. With Léger, Kupka and others painted pure colour compositions, a type of Cubism named by Guillaume Apollinaire at the Salon d'Automne of 1912 as Orphism. In *Windows* and *Disks* series, 1912–13, explored abstract qualities of colour. Pioneer of geometric abstraction.

GABO, Naum. 1890–1977
Russian. Born Briansk; died Waterbury, Connecticut. Studied engineering in Munich, where he met Kandinsky and other members of the *Blaue Reiter* group. Took up sculpture, 1914, and influenced by Cubism constructed first geometrical work. Returned to Russia, 1917. With Vladimir Tatlin and Alexander Rodchenko pioneered Constructivism and the creation of three-dimensional geometric abstractions in plastic and other man-made materials. With his brother Antoine Pevsner published *Realist Manifesto*, 1920. Returned to Germany, 1921. Member of the *Abstraction–Création* group in Paris, 1932. Moved to England, 1932. Collaborated with Nicholson on publication of periodical *Circle*, 1937. Settled in United States, 1946.

KANDINSKY, Wassily. 1866–1944
Russian/French. Born Moscow; died Neuilly-sur-Seine. Studied politics, economics and law at Moscow University. Moved to Munich to study painting, 1896, graduating from Munich Academy, 1901. Painted from nature in late-Impressionist manner, at the same time painting decorative scenes close in feeling to Russian folk art. Exhibited at the Salon d'Automne, 1904–10. Rented house at Murnau, Bavaria, 1908. Produced glass paintings and began to 'abstract' motifs from the local landscape, at the same time developing his theories on colour, line and form, and analogies between painting and music. Organized exhibitions for the *Blaue Reiter* group, 1911 and 1912, formed 'To give expression to inner impulses in every form which provokes an intimate reaction in the beholder'. With Franz Marc edited *Blaue Reiter Almanac*, 1912. Published his theories on 'non-objectivity' in *Concerning the Spiritual in Art*, 1912. Returned to Russia, 1914. Taught at and reorganized Russian art institutions, 1917–21. Left Russia, 1921. Took up post at Bauhaus, 1922. Moved with Bauhaus to Dessau, 1925, and Berlin, 1932. Published *Point and Line to Plane*, 1926. Settled at Neuilly-sur-Seine, 1933. Works shown at Nazi *Degenerate Art* exhibition, 1937. Forerunner of Abstract Expressionism and a major influence on the evolution of abstract art both as a painter and as a theorist.

KELLY, Ellsworth. Born 1923
American. Born Newburgh, New York. Studied at Pratt Institute, Brooklyn. Served in U.S. Army in France, 1943–45. Studied at Boston Museum Art School. Lived in Paris,

1948–54, gradually turning from figure subjects to compositions abstracted from natural forms and architecture. Visit to Arp's studio made a strong impression and during 1950s experimented with Arp's 'chance' method of dropping torn paper on to a ground; also collage, automatic drawing and spilled-paint technique. Created composite works from assembly of panels of single, uniform colour. Returned to New York, 1954. One of principal exponents of hard-edge painting and attributed with creation of earliest shaped canvases.

KLEE, Paul. 1879–1940

Swiss. Born Münchenbuchsee, near Bern; died Muralto-Locarno. Studied at Munich Academy, 1898–1901. Toured Italy and visited Paris. Settled in Munich, 1906. Took part in second *Blaue Reiter* exhibition, 1912. Began to work in colour in preference to black and white, 1914. Publication of essay 'Creative Credo', 1920. Joined staff of Bauhaus, 1921. Participated in first Surrealist exhibition in Paris, 1925. Published *The Pedagogical Sketchbook*, 1925. Returned to Switzerland, 1933. Work included in *Degenerate Art* exhibition, 1937. His concern with improvisation and with art as a creative process was of great importance to later abstract painters, in particular the Abstract Expressionists.

KLINE, Franz. 1910–62

American. Born Wilkes-Barre, Pennsylvania; died New York. Studied in Art Department, Boston University, and Heatherley School of Art, London. Settled in New York, painting in a figurative manner. First abstract works, c.1946. By 1950 producing large-scale Abstract Expressionist works composed of calligraphic images in black on white ground. From 1958 introduced bold colour in his gestural paintings.

KUPKA, Frank. 1871–1957

Czech. Born Opocno, Bohemia; died Puteaux, near Paris. Studied at Prague School of Fine Arts and Academy of Fine Arts, Vienna. Moved to Paris, 1895. Illustrations for magazines. Exhibited at the Salon d'Automne of 1912. Showed there an entirely abstract painting composed of circular and elliptical areas of colour. Published *Creation in Abstract Art* in Prague. Associated with *De Stijl*, 1924, and *Abstraction–Création* group, 1931. One of the first to progress from Cubism to abstraction.

LECK, Bart van der. 1876–1958

Dutch. Born Utrecht; died Blaricum. Studied in Amsterdam. Moved to Laren, 1916. Associated with Mondrian and with launching of *De Stijl*, 1917. Worked towards abstraction in a series of works based on drawings made in Spain and Algeria in 1914. Illustrator, interior decorator and designer of textiles and ceramics. Later reverted to figuration.

LÉGER, Fernand. 1881–1955

French. Born Argentan; died Gife-sur-Yvette, near Paris. Trained and worked as architectural draughtsman. Studied painting in Paris. Associated with Cubists and in 1912 named by Guillaume Apollinaire as one of the exponents of Orphism. Geometrical reduction of figures, still life and landscape led to abstraction. Work after First World War dominated by cylindrical and tubular forms and preoccupation with machinery. Met and influenced by Le Corbusier, 1920.

LISSITZKY, El. 1890–1941

Russian. Born Smolensk; died Moscow. Studied engineering in Darmstadt. Returned to Russia, 1914. Absorbed Suprematism through contact with Malevich, then Constructivism. Involved with Soviet propaganda, 1919–20. Began *Proun* series of Constructivist paintings, 1919; prints published in Germany, 1923. Went to Berlin to organize exhibition of contemporary Russian art, 1922. Worked with Theo van Doesburg and Moholy-Nagy. Lived in Switzerland, 1923–26, publishing work in collaboration with Arp and with Schwitters. Moved to Hanover, 1926–28, where he designed an abstract gallery. Returned to Russia, 1928. Through his activities in Europe introduced Russian abstract art to the West.

LOEWENSBERG, Verena. Born 1912

Swiss. Born Zurich. Active as a painter from 1934. Exponent of concrete art, the creation of rigidly geometric images making no reference to the visible world.

LOUIS, Morris, 1912–62

American. Born Baltimore; died Washington. Studied at the Maryland Institute of Fine and Applied Arts, Baltimore. Worked in New York on the WPA–Federal Art Project. Changed his name from Morris Bernstein. Returned to Baltimore before settling in Washington, 1952. From 1954 developed fully autonomous method of abstract painting, pouring thinned acrylic paint on to unprimed or partially primed canvas. *Veil* series, 1954–60. Late paintings composed of irregular stripes of bright colour, often overlapping and merging.

MALEVICH, Kasimir. 1878–1935

Russian. Born Kiev; died Leningrad. Attended School of Painting, Sculpture and Architecture in Moscow. Designed décor and costumes for Futurist opera *Victory over the Sun*, 1913. Produced propaganda posters and postcards, 1914–15. Showed *Black Square* (painted 1913) and other Suprematist compositions at *Zero-Ten* exhibition in Petrograd (St Petersburg), 1915. Exhibited white-on-white paintings in Moscow, 1919. Teacher at Russian art academies. Visited Bauhaus for publication of *The Non-Objective World* (reprint and translation of Suprematist pamphlets), 1927. As important as Mondrian in laying the foundations of geometric abstraction. During 1920s abandoned abstraction, having brought it to a logical conclusion, and returned to figurative painting.

MATISSE, Henri. 1869–1954

French. Born Le Cateau-Cambrésis; died Vence. Studied at Académie Julien and at the École des Beaux-Arts, Paris. Principal exponent of Fauvism, a movement recognized and named at the Salon d'Automne, 1905. Use of colour proved to be decisive inspiration for a generation of American abstract painters, Newman and Kelly among them. His small number of abstract works were in the form of paper cut-outs, though he himself recognized no difference between figuration and abstraction.

MIRÓ, Joan. 1893–1983

Spanish. Born Montroig, near Barcelona; died Palma, Majorca. Studied painting in Barcelona. Influenced by Fauvism and, later, Cubism. Met Picasso in Paris, 1919. Prominent in development of Surrealism, exhibiting at first Surrealist exhibition, 1925. Consciously exploited element of chance in the manner of Arp and Klee while developing his own pictorial language of bizarre organic forms. Much of his work was on the borderline between figuration and abstraction.

MOHOLY-NAGY, Laszlo. 1895–1946

Hungarian. Born Bacsbarsod; died Chicago. Studied law. Moved to Vienna, 1919, where he came under the influence of Malevich, Gabo and Lissitzky. On teaching staff of Bauhaus, 1923–28. Published *The New Vision: from Material to Architecture*, 1925. Moved to London, 1935. Contributed an article to *Circle*. Settled in Chicago. Leading exponent of Constructivism and advocate of the integration of Fine Art with architecture and other forms of design.

MONDRIAN, Piet. 1872–1944

Dutch. Born Amersfoort; died New York. Attended Amsterdam Academy. Painted landscapes in an Impressionist and, later, Neo-Impressionist manner. Went to Paris, 1911, where his work soon showed the influence of Cubism. Stylistic progression from Cubism to abstraction illustrated in *Tree* series, 1908–12. Returned to the Netherlands, 1914. Met Van der Leck and Theo van Doesburg, 1916. With Van Doesburg formed the group *De Stijl* and the journal of the same name, 1917. Returned to Paris, 1919. By now no longer abstracting from nature but creating pure abstractions in limited horizontal and vertical forms and range of colours. Published *Neo-Plasticism*, 1920. Moved to London, 1938. Essay 'Plastic Art and Pure Plastic Art' published in *Circle*, 1937. Settled in New York, 1940. Painted *Boogie Woogie* series. A founder of geometric abstraction, exerting an important influence on all aspects of twentieth-century design.

NEWMAN, Barnett. 1905–70

American. Born and died New York. Studied at Art Students' League and City College, New York. Destroyed all his work of 1930s, including some paintings in Surrealist manner. Began to paint abstract canvases with fields of strong saturated colour and

vertical stripes, 1946. One of the earliest masters of colour-field painting and pioneer of use of large-scale canvases.

NICHOLSON, Ben. 1894–1982

British. Born Denham, Buckinghamshire; died Hampstead. Son of the painter Sir William Nicholson. Studied briefly at the Slade. Experimented with Cubism. First abstract painting, 1924. Produced earliest all-white painted relief, 1933, while sharing a studio in Hampstead with sculptor Barbara Hepworth. Member of *Abstraction–Création* group, 1933–35. Visited Mondrian in Paris, 1934. Contact with international *avant garde* led to Mondrian and Gabo taking refuge in England in 1930s. With Gabo and J.L. Martin produced publication *Circle*, 1937. Though never abandoning figuration entirely, he was the foremost British exponent of geometric abstraction.

POLLOCK, Jackson. 1912–56

American. Born Cody, Wyoming; died East Hampton. Studied at the Art Students' League, New York, 1930–33. Worked sporadically for WPA – Federal Art Project. Experimented with use of spray guns and airbrushes, 1938. Underwent Jungian analysis, 1938–41, and became interested in the role of the unconscious in art. First one-man exhibition at Peggy Guggenheim's Art of this Century gallery, 1943. Explored primitive imagery in works of the early 1940s. First drip paintings, 1947. Series of black paintings, 1950–52. Foremost painter of the New York School of Abstract Expressionists and the artist to whose work the term 'Action Painting' was first applied, 1952.

POONS, Larry. Born 1937

American. Born Tokyo. Studied music before attending Boston Museum Art School. Paintings of the 1960s characterized by dots of colour placed according to a horizontal, vertical and diagonal grid against a rich coloured ground, so generating a sense of movement and other optical effects. Dots replaced by streaks of more subdued colours in 1970s. Prominent in colour-field school of painting.

REINHARDT, Ad. 1913–67

American. Born Buffalo; died New York. Studied art history at Columbia University. Attended National Academy of Design, American Artists' School and Institute of Fine Arts, New York University. Joined American Abstract Artists group, 1937. Worked on WPA – Federal Art Project. Became associated in 1940s with Abstract Expressionism. Adopted uniform, all-over treatment of the canvas. Paintings became progressively darker and more austere, with geometric forms barely distinguishable from background. Early exponent of minimal art.

RILEY, Bridget. Born 1931

British. Born London. Studied at Goldsmiths' College and Royal College of Art, London. Principal British practitioner of Op Art. From early work entirely in black and white progressed to colour compositions, 1965.

ROTHKO, Mark. 1903–70

Russian/American. Born Dvinsk, Latvia; died New York. Arrived in United States, 1913. Studied at Yale University and briefly at Art Students' League, New York. A founder of The Ten group of Expressionists, 1935. Paintings show influence of Surrealism, and Miró in particular, in 1940s. Began to develop mature style, c.1947, characterized by large areas of thinly applied, glowing colour with undefined edges, generally incorporating a floating bar or lozenge shape. Late pictures comprise only two expanses of colour separated by horizontal division. In the tradition of Malevich, and later colour-field painters such as Newman, his paintings were intended to be objects of contemplation.

SCHWITTERS, Kurt. 1887–1948

German. Born Hanover; died Ambleside, Cumbria. Studied in Dresden. Exhibited Expressionist paintings in Berlin, 1918. In Hanover invented *Merz*, a version of Dada, the anti-art movement, 1919. Produced *Merz* magazine, 1923–32, and made *Merz* collages made from refuse. Shared with abstract painters the belief that representation obscures expression. 'Sonata' of nonsensical sounds recited at Bauhaus, 1924. Member of *Abstraction–Création* group, 1932. Work included in *Degenerate Art* exhibition, 1937. Left Germany for Norway, 1937. Fled to England, 1940.

STELLA, Frank. Born 1936
American. Born Malden, Massachusetts. Attended Phillips Academy, Andover, and art courses while studying history at Princeton University. Influenced first by Pollock and Kline, later by Newman. Moved to New York, 1958. Series of black pictures, 1958–60. Aluminium series using shaped canvases, 1960. Later adopted more complex formats including half and quarter circles, arc, fan and protractor shape. Reacted against sombre quality of earlier works in paintings in bright fluorescent colours.

VASARELY, Victor. Born 1908
Hungarian/French. Born Pécs, Hungary. Studied at Poldun-Volkmann Academy and Mühely Academy, Budapest, where he was influenced by Moholy-Nagy. Moved to Paris, 1930. Began to paint geometric abstractions exploiting element of ambiguity, 1947. Contributed to development of *Groupe de Recherche d'Art Visuel*, Paris. An originator of Op Art.

LIST OF ILLUSTRATIONS

13 Mondrian, *Composition with Blue and Yellow*, 1935. Oil on canvas, 28½ × 27¼ inches (73 × 69.8 cm). Hirshhorn Museum and Sculpture Garden, Smithsonian Institution, Washington, D.C. Gift of Joseph H. Hirshhorn Foundation, 1972.

14 Photograph of Mondrian in his Paris studio, c.1930. Gemeentemuseum, The Hague.

15 Photograph of Mondrian's studio, Paris, c.1931. Gemeentemuseum, The Hague.

16 Photograph of thatched windmills outside Alkmaar, Holland. Topham Picture Library.

17 Illustration of the foxtrot. Drawing by Liz Lock.

18 Mondrian, *The Red Tree*, 1908. Oil on canvas, 27⅓ × 38⅗ inches (70 × 99 cm). Gemeentemuseum, The Hague.
Mondrian, *The Blue Tree*, 1909–10. Oil on canvas, 29½ × 38⅘ inches (75.5 × 99.5 cm). Gemeentemuseum, The Hague.
Mondrian, *The Grey Tree*, 1912. Oil on canvas, 30⅖ × 42 inches (78.5 × 107.5 cm). Gemeentemuseum, The Hague.

19 Mondrian, *Flowering Apple Tree*, c.1912. Oil on canvas, 30¾ × 41¾ inches (78 × 106 cm). Gemeentemuseum, The Hague.

20 Illustration by Matthew Drury.

21 Klee, *Park near L(ucerne)*, 1938. Oil on canvas, 39 × 27¼ inches (100 × 70 cm). Kunstmuseum, Bern.

22 Photograph of Klee in his studio. Photo: Felix Klee, Bern.

22 Drawing by Frank Whitford.

24 Diagram from Klee's teaching manual, *The Pedagogical Sketchbook*, 1925.

26 Photography of Kandinsky. Topham Picture Library.

27 Kandinsky, *Improvisation No. 30*, 1913. Oil on canvas, 43 × 39 inches (110 × 100 cm). Art Institute of Chicago. Arthur Jerome Eddy Memorial Collection.
Kandinsky, *Amsterdam, View from the Window*, 1904. Oil on board, 9⅜ × 13 inches (24 × 33 cm). Solomon R. Guggenheim Museum, New York. Photo: David Heald.

28 Photograph of Cumulonimbus clouds. National Meteorological Library, London.

29 Photograph of Kandinsky at the Bauhaus, 1926. Photo: Felix Klee, Bern.

30 Photograph of abstract pattern English wallpaper, 1920–30. Victoria and Albert Museum, London.

30 Drawing by Frank Whitford.

31 Matisse, *The Snail*, 1953. Gouache on cut-out and pasted paper, 112¾ × 113 inches (286 × 287 cm). Tate Gallery, London.

32 Photograph of Matisse in his studio by Brassaï, c.1930. Photo: Sotheby's, London.

33 Photograph of Freud by André Perlstein, 1920. Camera Press, London.

34 Pollock, *Alchemy*, 1947. Oil on canvas, 45 × 87 inches (114 × 195.5 cm). Peggy Guggenheim Collection, Venice (Solomon R. Guggenheim Foundation).

36 Photograph of Pollock with Peggy Guggenheim. Peggy Guggenheim Collection, Venice (Solomon R. Guggenheim Foundation).
Curtis, *Indians on Horseback*. Photo: Sotheby's, London.

37 Navajo sand painting. Horniman Museum, London.

37 Photograph of Paul Newman as Abstract Expressionist in *What A Way To Go*, 1969. British Film Institute.

39 Schwitters, *Of South Africa*, 1937–38. Collage, 7½ × 6½ inches (19.1 × 16.6 cm). Marlborough Fine Art (London) Ltd.

40 Photograph of Schwitters by Ernst Schwitters. Photo: Marlborough Fine Art (London) Ltd.
Photograph of rubbish by Mike Burns.

42 Photograph of Riley in her studio, London, 1984. Contemporary Art Society. Photo: Juda Rowan Gallery, London.
Riley, *Untitled study*. Gouache on graph paper. Juda Rowan Gallery, London.

43 Riley, *Cataract 3*, 1967. Emulsion PVA on linen, 86½ × 87 inches (221.9 × 222.9 cm). British Council Fine Arts Department, London.

44 Photograph of Miró at Matisse exhibition. Topham Picture Library.

45 Miró, *Tic Tic*, 1927. Oil on canvas, 9½ × 13 inches (24 × 33 cm). Kettle's Yard, University of Cambridge.

46 Photograph of 'Insecta Coleoptera' (Scuttling Beetle). Oxford Scientific Films Picture Library, Oxford.

47 Malevich, *Suprematist Composition: White on White*, 1917–18. Oil on canvas, 31½ × 31¼ inches (79.4 × 79.4 cm). Museum of Modern Art, New York.

48 Allais, *First Communion of Anaemic Young Girls in the Snow*, 1883 (Reconstruction).
Allais, *Apoplectic Cardinals Harvesting Tomatoes on the Shore of the Red Sea*, 1884 (Reconstruction).

49 Malevich, *Black Square*. Printed version from an anthology of Malevich drawings, 1920.

50 Photograph of Malevich in 1900. Novosti Press Agency, London.

52 Newman, *Cathedra*, 1951. Oil and Magna on canvas, 93⅗ × 211 inches (240 × 543.5 cm). Stedelijk Museum, Amsterdam.
Portrait of Newman. Photo: Mrs Barnett Newman.

55 David, *Rape of the Sabines*, 1799. Oil on canvas, 150 × 203⅗ inches (385 × 522 cm). Louvre, Paris.

55 Delacroix, *Death of Sardanapalus*, 1827. Oil on canvas, 152⅘ × 193⅖ inches (392 × 496 cm). Louvre, Paris.

56 Louis, *Third Element*, 1962. Synthetic polymer paint on canvas, 85¾ × 51 inches (207.5 × 129.5 cm). Museum of Modern Art, New York. Blanchette Rockefeller Fund.

59 Louis, *Overlapping*, 1959–60. Acrylic on canvas, 91½ × 140 inches (232.4 × 355.6 cm). Christie's, New York. Collection Mr and Mrs Burton Reswick, New York.

62 Cave painting from Lascaux, c.16000–14000 BC. Photo: Hans Hinz.

63 Drawing by Frank Whitford.
Monet, *Route à Louveciennes, neige fondant, soleil couchant*, 1870. Photo: Lefèvre Gallery, London.

64 Drawings by Frank Whitford.

65 Van Eyck, *Betrothal of the Arnolfini*, 1434. Oil on oak panel, 32¼ × 23½ inches (81.8 × 59.7 cm). National Gallery, London.
Vermeer, *The Art of Painting*, c.1666. Oil on canvas, 51¼ × 43¼ inches (130 × 110 cm). Kunsthistorisches Museum,

Vienna.

66 Collier, *Trompe l'œil painting*, c.1695–1700. Oil on canvas. Tate Gallery, London.
Hogarth, *Moses Brought before Pharoah's Daughter*, c.1764. Oil on canvas, 68 × 82 inches (172.7 × 208.3 cm). Thomas Coram Foundation for Children, London.

67 Constable, *The Glebe Farm*, c.1830. Oil on canvas, 23½ × 30¾ inches (59.7 × 78.1 cm). Tate Gallery, London.
Turner, *Snow Storm: Hannibal and his Army Crossing the Alps*, 1812. Oil on canvas, 56¾ × 92½ inches (146 × 237.5 cm). Tate Gallery, London.

68 Manet, *Déjeuner sur l'herbe*, 1863. Oil on canvas, 81 × 103 inches (208 × 264 cm). Musée d'Orsay, Paris.

69 Manet, *Olympia*, 1863. Oil on canvas, 50¾ × 74 inches (130.5 × 190 cm). Musée d'Orsay, Paris.

70 Whistler, *Arrangement in Grey and Black No. 1 (The Artist's Mother)*, 1867–72. Oil on canvas, 56 × 63 inches (144 × 162 cm). Musée d'Orsay, Paris.

71 Whistler, *Nocturne in Blue and Gold: Old Battersea Bridge*, 1872–75. Oil on canvas, 26¾ × 20 inches (67.9 × 50.8 cm). Tate Gallery, London.

72 Munch, *The Scream*, 1893. Mixed media on paper, 35½ × 28½ inches (91 × 73.5 cm). Nasjonalgalleriet, Oslo. Photo: Jacques Lathion.

73 Sérusier, *Landscape of the Bois d'Amour at Pont-Aven: The Talisman*, 1888. Oil on wood, 10⅝ × 8⅝ inches (26.9 × 21.8 cm). Photo: Giraudon.

74 Gauguin, *Vision After the Sermon: Jacob Wrestling with the Angel*, 1888. 28¾ × 36¼ inches (73 × 92 cm). National Gallery of Scotland, Edinburgh.

75 Gauguin, *Manao Tupapau (Spirit of the Dead Watching)*, 1892. Oil on burlap mounted on canvas, 28½ × 36⅜ inches (72.4 × 92.4 cm). Albright-Knox Art Gallery, Buffalo, New York. A. Conger Goodyear Collection, 1965.

76 Van Gogh, *Night Café*, 1888. Oil on canvas, 28½ × 36¼ inches (72.4 × 92.1 cm). Yale University Art Gallery, New Haven, Connecticut. Bequest of Stephen Carlton Clarke B.A., 1903.

79 Luce, *Portrait of Signac*. Black and blue chalk on white paper, 8 × 7 inches (20.3 × 17.8 cm). Formerly collection of the late Benjamin Sonnenburg. Photo: John Calmann and King Ltd.

80 Seurat, *Invitation to the Sideshow (La Parade)*, 1887–88. Oil on canvas, 39¼ × 59 inches (99.7 × 149.9 cm). Metropolitan Museum of Art, New York. Stephen C. Clark Bequest.

81 Seurat, *Circus*, 1890–91. Oil on canvas, 73 × 59⅛ inches (185 × 150.2 cm). Musée d'Orsay, Paris.

82 Photograph by Baldus of the Pont du Gard, Nîmes, c.1860. Sotheby's, London.

83 Cézanne, *Still life with Plaster Cupid*, c.1895. Oil on paper on board, 27½ × 22½ inches (70 × 57 cm). Courtauld Institute Galleries, University of London.

84 Friedrich, *Traveller Looking over the Sea of Fog*, c.1818. Oil on canvas, 37 × 29 inches (94.8 × 74.8 cm). Kunsthalle, Hamburg.

85 Drawings by Frank Whitford.

87 Monet, *Haystack at Sunset*, 1891. Oil on canvas, 28⅞ × 36½ inches (73.3 × 92.6 cm). Museum of Fine Arts, Boston, Juliana Cheney Edwards Collection.

89 Illustration by Zvorykin of a Russian fairy tale.
Kandinsky, *Russian Beauty in a Landscape*, 1905. Gouache on black paper, 16¼ × 11¼ inches (41.3 × 28.6 cm). Städtische Galerie im Lenbachhaus, Munich.

90 Kandinsky, *Painting with Houses*, 1909. Oil on canvas, 37 × 50¾ inches (97 × 130 cm). Stedelijk Museum, Amsterdam.
Kandinsky, *Murnau with Rainbow*, 1909. Oil on cardboard, 12¾ × 16¾ inches (33 × 43 cm). Städtische Galerie im Lenbachhaus, Munich.

91 Kandinsky, *Nature Study from Murnau I*, 1909. Oil on cardboard, 12⅞ × 17⅜ inches (32.9 × 44.6 cm). Städtische Galerie im Lenbachhaus, Munich.

92 *Glass painting of St Luke*, 1800. Upper Bavaria. Heimatmuseum der Gemeinde, Oberammergau.
Kandinsky, *Sancta Francisca*, 1911. Oil on glass, 6⅛ × 4⅝ inches (15.6 × 11.8 cm). Solomon R. Guggenheim Museum, New York.

93 Kandinsky, *All Saints' Day*, 1911. Oil on canvas, 33⅞ × 39 inches (86 × 99 cm). Städtische Galerie im Lenbachhaus, Munich.

94 Kandinsky, *Cossacks (Study for Composition 4)*, 1910–11. Oil on canvas, 36¾ × 51 inches (94.5 × 131.5 cm). Tate Gallery, London.

96 Kandinsky, *In The Blue*, 1925. Oil on cardboard, 31½ × 43¼ inches (80 × 110 cm). Kunstsammlung Nordrhein–Westfalen, Düsseldorf.

97 Kandinsky, *White-soft and Hard*, 1932. Oil and gouache on canvas, 31½ × 39⅜ inches (80 × 100 cm). Museum of Modern Art, New York. Riklis Collection of McCrory Corporation.
Picasso, *Still Life with Chair Caning*, 1912. Collage of oil, oil cloth and paper on canvas surrounded with rope, (oval) 10½ × 13¾ inches (27 × 35 cm). Musée Picasso, Paris.

99 Braque, *Mandola*, 1909–10. Oil on canvas, 28½ × 22¾ inches (72.5 × 60 cm). Tate Gallery, London.

100 Delaunay, *Simultaneous Contrasts: Sun and Moon*, 1913. Oil on canvas, diameter 53 inches (134.5 cm). Museum of Modern Art, New York. Mrs Simon Guggenheim Fund.
Kupka, *The Disks of Newton*, 1911–12. Oil on canvas, 19½ × 25⅝ inches (49.5 × 65 cm). Musée National d'Art Moderne, Paris.

101 Léger, *Contrast of Forms*, 1913. Oil on canvas, 39½ × 32 inches (100 × 81 cm). Musée National d'Art Moderne, Paris.

103 Severini, *Suburban Train Arriving in Paris*, 1915. Oil on canvas, 34⅞ × 45½ inches (89 × 116 cm). Tate Gallery, London.

105 Balla, *Abstract Speed – the Car has Passed*, 1913. Oil on canvas, 19¾ × 25¾ inches (50 × 65.3 cm). Tate Gallery, London.

106 Malevich, *Woman with Water Pails: Dynamic Arrangement*, 1912. Oil on canvas, 31⅝ × 31⅝ inches (80.3 × 80.3 cm). Museum of Modern Art, New York.

107 Malevich, *Suprematist Composition: Airplane Flying*, 1914. Oil on canvas, 22⅞ × 19 inches (58.1 × 48.3 cm). Museum of Modern Art, New York.

108 Van der Leck, *Study for Arabs on Donkeys*, 1915. Charcoal and water-colour on paper, 11¾ × 20¾ inches (30 × 52.2 cm). Rijksmuseum Kröller-Müller, Otterlo.
Van der Leck, *Study for Composition 1917 No. 5 (Donkey Riders)*, Gouache, 25¼ × 58½ inches (65 × 150 cm). J. P. Smid,

155

Kunsthandel Monet, Amsterdam.

109 Gabo, *Model for Rotating Fountain*, 1925 (reassembled 1986). Family Collection.
Van der Leck, *Study for Composition 1917 No. 6 (Donkey Riders)*, 1917. Gouache, 23¾ × 58½ inches (61 × 150 cm). J. P. Smid, Kunsthandel Monet, Amsterdam.

110 Rietveld, *Red and Blue Chair*, 1918. Painted wood, 33⅞ × 25⅛ × 26¾ inches (86 × 63 × 67.9 cm). Stedelijk Museum, Amsterdam.

111 Maholy–Nagy, *K VII*, 1922. Oil on canvas, 45⅜ × 53½ inches (115.5 × 136 cm). Tate Gallery, London.

113 Ernst 'There remains then he who speculates upon the vanity of the dead, the spectre of repopulation', *La Femme 100 Têtes*, 1929. Collage illustration.
Masson, *Automatic drawing*, reproduced in *La Révolution Surréaliste*, No. 3, 1925.

117 Luini, *Head and Shoulders of a Young Woman*, early sixteenth century. Panel transferred to canvas, 13¾ × 10¾ inches (35 × 27.3 cm). Christie's, London.
Leonardo da Vinci, *Madonna of the Rocks*, late fifteenth century. National Gallery, London.

118 Mondrian, *Composition with Blue and Yellow*, 1935. Oil on canvas, 28¾ × 27¼ inches (73 × 62.2 cm). Hirshhorn Museum and Sculpture Garden, Washington, D.C.
Loewensberg, *No. 50*, 1942. Oil on canvas, 21¾ × 21¾ inches (56 × 56 cm). Photo: Juda Rowan Gallery.

119 Pollock, *Echo (No. 25, 1951)*, 1951. Enamel paint on canvas, 91⅞ × 86 inches (223 × 218 cm). Museum of Modern Art, New York. Lillie B. Bliss Bequest and the Mr and Mrs David

Rockefeller Fund.
Congo the chimp. Photo: Times Newspapers Ltd.

120 Schulz Peanuts cartoon strip. *Daily Mail*.
Scully cartoon, 1952. Associated Newspapers Group Ltd.

121 Peter Arno cartoon, *New Yorker*, 26 December 1953.
Titian, *Diana and Actaeon*, c.1559. Oil on canvas, 70⅜ × 78 inches (178.8 × 198.1 cm). National Gallery, London.

122 Rothko, *Red, White and Brown*, 1957. Oil on canvas, 38½ × 81 inches (252.5 × 207.5 cm). Kunstmuseum, Basel. Photo: Hans Hinz.

123 Lissitzky, *Beat the Whites with the Red Wedge*, 1919–20. Poster, 23 × 19 inches (58 × 48 cm).

131 Arp, *Birthday Composition*, 1962. Painted wood relief, diameter 10½ inches. Photo: Christie's, New York.

133 Nicholson, *Painted relief*, 1939. Oil on carved board, 14⅞ × 26 inches (37.8 × 66 cm). Marlborough Fine Art (London) Ltd.

135 Kline, *Untitled Painting*, 1961. Oil on canvas, 32 × 28 inches (81.5 × 71 cm). Photo: Christie's, New York.

137 Poons, *Zorns Lemma*, 1963. Acrylic on canvas, 90 × 80 inches (228.5 × 203 cm). Estee Lauder, Inc. Photo: Christie's, New York.

139 Vasarely, *Supernovae*, 1959–61. Oil on canvas, 95¼ × 60 inches (242 × 152 cm). Tate Gallery, London.

141 Kelly, *Red-orange Blue*, 1964–65. Oil on canvas, 69 × 51 inches (175.2 × 129.5 cm). Collection Frederick R. Weisman. Photo: Christie's, New York.

143 Stella, *Itata*, 1964. Metallic powder in polymer emulsion on canvas – unframed, 77½ × 133¾ inches (197 × 340 cm). Photo: Christie's, New York.

145 Reinhardt, *Black on Black No. 8*, 1953. Oil on canvas, 80 × 60 inches (203.2 × 152.4 cm). Photo: Christie's, New York.

BIBLIOGRAPHY

The following is by no means an exhaustive bibliography. Divided into categories both general and specific, it lists books likely to be of interest to the general reader and likely to be available in good public libraries. There is a bias in favour of recent publications.

MODERN ART
Arnason, H.H., 'A History of Modern Art', 1969
Chipp, Herschel B. (ed.), 'Theories of Modern Art', 1968
Haftmann, Werner, 'Painting in the Twentieth Century', 1968
Hamilton, George Heard, 'Painting and Sculpture in Europe 1880–1940', 1967
Hofmann, Werner, 'Turning Points in Twentieth Century Art', 1969
Hughes, Robert, 'The Shock of the New, 1980
Lynton, Norbert, 'The Story of Modern Art', 1980
Open University, 'Modern Art 1848 to the Present' (Course Units), 1975–76
Richardson, Tony, and Stangos, Nikos (ed), 'Concepts of Modern Art', 1974
Rosenblum, Robert, 'Cubism and Twentieth-century Art', 1961
Schapiro, Meyer, 'Modern Art', 1978
Steinberg, Leo, 'Other Criteria: Confrontations with Twentieth-century Art', 1972

ABSTRACT ART
Gardiner, Henry G., 'Color and Form 1909–1914. The Origin and Evolution of Abstract Painting in Futurism, Orphism, Rayonnism, Synchronism and the Blue Rider', 1971
Barr, Alfred H., 'Cubism and Abstract Art', 1936
Seuphor, Michel, 'Abstract Painting from Kandinsky to the Present', 1962 'A Dictionary of Abstract Painting Preceded by a History of Abstract Painting', 1958
Tate Gallery, 'Towards a New Art: Essays on the Background to Abstract Art, 1910–1920', 1980.

CUBISM
Cooper, Douglas, 'The Cubist Epoch', 1970
Golding, John, 'Cubism, a History and an Analysis, 1907–14', 1959

FUTURISM
Tisdall, Caroline, and Bozzolla, Angelo, 'Futurism', 1977

DE STIJL
Jaffé, H.L.C., 'De Stijl 1917–1931', 1956
Overy, Paul, 'De Stijl', 1969

RUSSIAN ABSTRACTION
Bowlt, John E. (ed), 'Russian Art of the Avant-Garde: Theory and Criticism. 1902–1934', 1976
Gray, Camilla, 'The Great Experiment: Russian Art 1863–1922', 1962

FRENCH ABSTRACTION
Spate, Virginia, 'Orphism: The Evolution of Non-figurative Painting in Paris, 1910–14', 1979

AMERICAN ABSTRACTION
Ashton, Dore, 'The New York School', 1973
Hobbs, Robert C., and Levin, Gail, 'Abstract Expressionism: the Formative Years', 1981
Osborne, Harold, 'Abstraction and Artifice in Twentieth-century Art', 1979
Sandler, Irving, 'Abstract Expressionism: the Triumph of American Painting', 1970
Tuchman, Maurice (ed), 'The New York School', 1970

INDIVIDUAL ARTISTS

DELAUNAY
Hoog, Michel, 'Robert Delaunay', 1976
KANDINSKY
Overy, Paul, 'Kandinsky: The Language of the Eye', 1969
Weiss, Peg, 'Kandinsky in Munich: the Formative Jugendstil Years', 1979
KELLY
Coplans, John, 'Ellsworth Kelly', 1971
KLEE
Geelhaar, Christian, 'Paul Klee and the Bauhaus', 1973
Haftmann, Werner, 'The Mind and Work of Paul Klee', 1967
KLINE
Whitechapel Art Gallery, London, 'Franz Kline, a Retrospective', 1964
KUPKA
Solomon R. Guggenheim Museum, New York, 'Frantisek Kupka, 1871–1957. A Retrospective Exhibition', 1975
LÉGER
Francia, Peter de, 'Fernand Léger', 1983
LOUIS
Fried, Michael, 'Morris Louis 1912–1962', 1970
MALEVICH
Andersen, Troels, 'Malevich', 1970
Zhadova, Larissa A., 'Malevich: Suprematism and Revolution in Russian Art 1910–1930', 1982
MATISSE
Flam, Jack D. (ed), 'Matisse on Art', 1973
Gowing, Lawrence, 'Henri Matisse', 1979
MIRÓ
Penrose, Roland, 'Joan Miró', 1970
Sweeny, James Johnson, 'Joan Miró', 1970
MONDRIAN
Hunter, Sam, 'Piet Mondrian', 1978
Seuphor, Michel, 'Piet Mondrian: Life and Work', 1957
NEWMAN
Hess, Thomas B., 'Barnett Newman', 1969
Rosenberg, Harold, 'Barnett Newman', 1978
POONS
Wood, James N., 'Six Painters', 1971
POLLOCK
Friedman, B.H., 'Jackson Pollock', Energy Made Visible 1972
REINHARDT
Lippard, Lucy, 'Ad Reinhardt', 1981
RILEY
Kudielka, Robert, 'Bridget Riley – Works 1959–78', 1978
Sausmarez, Maurice de, 'Bridget Riley', 1970
ROTHKO
Waldman, Diane, 'Mark Rothko 1903–70', 1978
Ashton, Dore, 'About Rothko', 1983
SCHWITTERS
Elderfield, John, 'Kurt Schwitters', 1985
STELLA
Rubin, William S., 'Frank Stella', 1970
VASARELEY
Spies, Werner, 'Victor Vasarely', 1971

LIST OF QUOTATIONS

15 Mondrian. Translation from Michel Seuphor, 'Piet Mondrian: Life and Work' (Abrams, New York, 1957).

23 Klee. Translation by Norbert Guterman from 'The Inward Vision: Watercolours, Drawings and Writings' by Paul Klee (Abrams, New York, 1959).

37 Rosenberg. Action Painters article in 'Art News' (New York, Dec, 1952).

41 Schwitters. Translation by Ralph Manheim from 'The Dada Painters and Poets' (Wittenborn, Schultz, New York, 1951).

46 Miró. From an interview with Georges Duthuit, 1936. Translation by James Johnson Sweeney.

49 Malevich. Translation by Howard Dearstyne from 'The Non-Objective World' (Theobald, Chicago, 1959).

86 & 87 Kandinsky. Translation by Peter Vergo from the Tate Gallery catalogue, 'Abstraction: Towards a New Art. Painting 1910–20', 1980.

101 & 103 F. T. Marinetti, 'Futurist Manifesto' (1909).

INDEX

Numbers in *italics* refer to illustrations.

A
Abstract Expressionism 37, 119, 134, 136, 142, 144
abstracting 20, 22, 26, 44, 72, 92, 93, 97, 101, 130, 132
accident *see* chance
Action Painting 37
Allais, Alphonse 48, *48*
allegory 64–65
American Indians *36, 37*, 54
Apollinaire, Guillaume 37, 98, 101
Arp, Hans (Jean) 32, 130, 149; *Birthday Composition 131*
artists' statements on art; Denis 83; Gauguin 72, 75, 78; Gogh, Van 75, 78; Kandinsky 26, 28, 86, 87–89; Klee 23–24; Kline 134; Malevich 49–51, 138; Matisse 32, 33; Miró 46; Mondrian 15–16; Nicholson 132; Pollock 37; Reinhardt 144; Seurat 80
automatic techniques 52, 112, *113*, 134

B
Balla, Giacomo 104, 106, 149; *Abstract Speed – the Car has Passed 105*
battle scene 26, *27*, 28, *95*
Bauhaus 22, 26, *29*, 97, 110
Berlin 41
Blaue Reiter Almanac 92
Boccioni, Umberto 103, 104
Bolshevik revolution *see* Russian Revolution
Braque, Georges 18, 97–98, *99*, 101
Brassai, G.H. 32
Breton, André 112

C
calligraphy 18, 134, 136
Carrà, Carlo 104
cartoon *120, 121*
Cézanne, Paul 50, 60, 63, 72, 82–83, *83*, 97
chance, role of 32, 33, 36, 44, 46, 58, 112, 120, 125, 132
children's art 20, *20*, 25
cinema 9
collage 32, 38, *39*, 40–41, 49, 60, 98, 112, *113*
Collier, Edward *66*
colour-field painting 136, *137*, 140, 144
Concerning the Spiritual in Art (Kandinsky) 86, 87–89

concrete art 8, 15, 16
Congo the chimpanzee *119*, 120
Constable, John 67, *67*, 124
Constructivism 109, 110, 138, 140, 142
'Creative Credo' (Klee) 23–24, 25
Cubism 18, 37, 50, 54, 60, 97–98, 101, 105, 109, 132, 142, 144

D
David, Jacques Louis 54, *55*
Delacroix, Eugène 54, *55*
Delaunay, Robert 98, 101, 149; *Simultaneous Contrasts: Sun and Moon 100*
Denis, Maurice 83
Divisionism 79
Doesburg, Theo van 110
drip painting 38

E
Ede, Jim 44
Egyptian art 62, 63, *63*
Ernst, Max 112, *113*
Expressionism 54
Eyck, Jan Van 64, *65*

F
Fauvism 18
First World War 23, 96, 97, 101, 110, 112, 114
foxtrot 17, *17*
Freud, Sigmund 33, *33*, 46, 112
Friedrich, Caspar David *84*, 85
Futurism 101–6, 107, 109, 112

G
Gabo, Naum 109, 149; *Model for Rotating Fountain 109*
Gauguin, Paul 72, 74–75, *74, 75*, 78, 80, 82, 83, 85
geometric abstraction 48, 60, 96, 97, 110, 113, 114, 128, 130, 132, *133*, 138, 140, 144
gestural painting 60, 134, *135*, 136, 144
glass painting 92, *92*
Gogh, Vincent van 75, *76*, 78, 79, 82
graph paper 41, 42, *42*, 44
Gropius, Walter *29*
Guggenheim, Peggy *36*

H
hard-edge painting 140, *141*, 144
Henry, Charles 79
Hogarth, William 66, 67

I
ideogram 20
Impressionism 50, 60, 63, 72, 83, 91, 125
improvisation 32, 36–38, 44, 96
Islamic art 22, *23*, 25

K
Kandinsky, Wassily 8, 9, 26, *26*, 28–30, *29*, 32, 37, 60, 83, 85–89, 91–93, 96–97, 107, 110, 113, 114, 116, 130, 134, 149; *All Saints' Day II 93; Amsterdam, View from the Window 28; Cossacks (Study for Composition 4);* 93, 94, *95; Improvisation No. 30* 26, *27*, 28–30; *In the Blue 96*, 97; *Murnau with Rainbow 90; Nature Study from Murnau I 91; Painting with Houses 90; Russian Beauty in a Landscape 89; Sancta Francisca 92; White-soft and Hard 97*
Kelly, Ellsworth 140, 144, 149; *Red-orange Blue 141*
Klee, Paul 20, 22–26, *22*, 29, *29*, 37, 48, 58, 60, 110, 128, 130, 150; *Park near L(ucerne) 20, 21, 58, 129*
Kline, Franz 134, *135*, 150
Kupka, Frank 98, 150; *The Disks of Newton 100*

L
landscape 8, 19, 24, 25, 26, 66, 67, 80, 97, 101, 130; American West *36, 37*; Dutch 16, *16*, 17, 37
Lascaux 62
Leck, Bart van der 110, 150; *Study for Arabs on Donkeys 108; Study for Composition 1917 No. 5 (Donkey Riders) 108; Study for Composition 1917 No.6 (Donkey Riders) 109*
Léger, Fernand 101, 150; *Contrast of Forms 101*
Leonardo da Vinci 49, 66, 112, 117, *117*, 119
Lissitzky, El 123, 142, 150; *Beat the Whites with the Red Wedge 123*
Loewensberg, Verena 119; 150: *No. 50 118*
Louis, Morris 58–59, *58*, 60, 125, 151; *Overlapping 59; Third Element 56*, 58–59
Luini, Bernardino 117, *117*, 119

M
Malevich, Kasimir 9, 46, 48–52, *50*, 53, 96, 107, 109, 113, 114, 128, 132, 138, 140, 142, 144, 151; *Black Square 49, 49*, 50, 51, 107; *Suprematist Composition:*

Airplane Flying 107, *107*; *Suprematist Composition: White on White* 46, *47*, 48–52, *129*; *Woman with Water Pails 106*, 107
Manet, Edouard 68–70, *68*, *69*
Manifesto of Futurist Painting 104
Marc, Franz 92
Marinetti, F.T. 101–4
Masson, André 112, 113, *113*
Matisse, Henri 23, 30, 32–33, *32*, 37, 58, 60, 140, 151; *The Snail* 30, *31*, 32–33, 58
Milan 101
minimal art 144, *145*
Miró, Joan 44, *44*, 46, 48, 113, 130, 151; *Tic Tic* 44, *45*, 46, 60
Moholy-Nagy, Laszlo 42, 110, 151; *K VII 111*
Mondrian, Piet 9, 12, 13–20, *14*, *15*, 22, 25, 26, 29, 30, 32, 37, 46, 48, 51, 54, 58, 60, 107, 109–110, 113, 114, 116, 119, 124, 125, 128, 132, 142, 151; *Composition with Blue and Yellow* 12, *13*, 14–20, 107, *118*, *129*; *Flowering Apple Tree 19*; *The Blue Tree 18*; *The Grey Tree 18*; *The Red Tree 18*
Monet, Claude 63, *63*, 86, *87*, 97
Moscow 86, 87
Munch, Edvard 72, *72*
Munich 89, 91, 92
Murnau *90*, 91, *91*, 92, 93
music, analogies with 17, 70, 72, 75, 78, 79, 83, 85–86, 96

N
'Natural Reality and Abstract Reality' (Mondrian) 15–16
Neo-plasticism 8, 15–16
Newman, Barnett 53–54, *54*, 58, 125, 136, 144, 151; *Cathedra 52*, 53–54, 58
New York 54, 136
Nicholson, Ben 132, 152; *Painted relief 133*
non-objectivity 8, 86, 97

O
October Revolution *see* Russian Revolution

Op Art 106, 138, *139*, 140, *141*, 144; *see also* Riley
organic abstraction 48, 52, 60, 97, 113, 114, 128, 130, *131*, 132, 140, 144
Orphism 101

P
paper cut-out *31*, 32, 140
Paris 18, 46, 97, 98, 110, 112, 114, 116
Pedagogical Sketchbook, The (Klee) 24, *24*
Petrograd 107
photography 64, *82*, 83
Picasso, Pablo 18, 97–98, *97*, 101, 114
pictogram 22, *22*, 125, 142
poetry, analogies with 9, 72, 85, 102
Pointillism *see* Divisionism
Pollock, Jackson 9, 33, 36–38, *36*, 41, 44, 52, 53, 60, 119, 120, 125, 128, 130, 134, 136, 152; *Alchemy* 33, *34*, 36–38, *129*; *Echo 119*
Poons, Larry 136, 140, 152; *Zorns Lemma 137*
psychoanalysis 33
psychology 78, 83, 85, 88, 101, 138

R
Read, Herbert 8
Reinhardt, Ad 144, 152; *Black on Black No. 8 145*
Rietveld, Gerrit 110, *110*
Riley, Bridget 42, *42*, 44, 46, 60, 106, 138, 152; *Cataract 3 42*, *43*, 44
Rodchenko, Alexander 109
Rosenberg, Harold 37
Rothko, Mark 123, 136, 144, 152; *Red, White and Brown 122*
Ruskin, John 124
Russian Revolution 48, 49, 106–7, 109, 123, 124

S
sand painting *37*
Schönberg, Arnold 85
Schwitters, Kurt 38, 40–42, *40*, 60, 152;

Of South Africa 38, *39*, 40–42
Scriabin, Alexander 85
sculpture 9–10, 32, 66, 104, 109, 132, 142
Second World War 114, 132
Sérusier, Paul 72, *73*
Seurat, Georges 79–80, *80*, *81*, 82, 83, 105
Severini, Gino *103*, 104
shaped canvas 142, *143*
Signac, Paul 79, *79*
Stella, Frank 142, 144, 153; *Itata 143*
Stijl, De 109–110
still life 66, 67, *83*, 97, 98, 101, 132
studios; Klee *22*; Matisse *32*; Mondrian *14*, *15*, 17; Riley *42*
subconscious, role of 33, 46, 112, 136
Suprematism *47*, 49–51, 96, 107, *107*, 109
Surrealism 46, 52, 112, 113, 114, 116, 134, 144
symbolism 64, 74, 78
synaesthesia 83

T
tachism 134
Tatlin, Vladimir 109
theories on art 10, 19, 48, 60, 85, 107, 116; *see also* artists' statements on art
Titian 121, *121*
Tretyakov Gallery, Moscow 86, *87*
trompe l'œil 66, *66*
Turner, J.M.W. 38, 67, *67*

V
Vasarely, Victor 138, 153; *Supernovae 139*
Vermeer, Jan 65, *65*

W
wallpaper 9, 30, *30*, 114
Whistler, J.A.M. 70, *70*, *71*, 83, 85, 124

Z
Zero-Ten exhibition 107
Zvorykin, Boris *89*